ALL COLOR BOOK OF
ART NOUVEAU

BY GEOFFREY WARREN

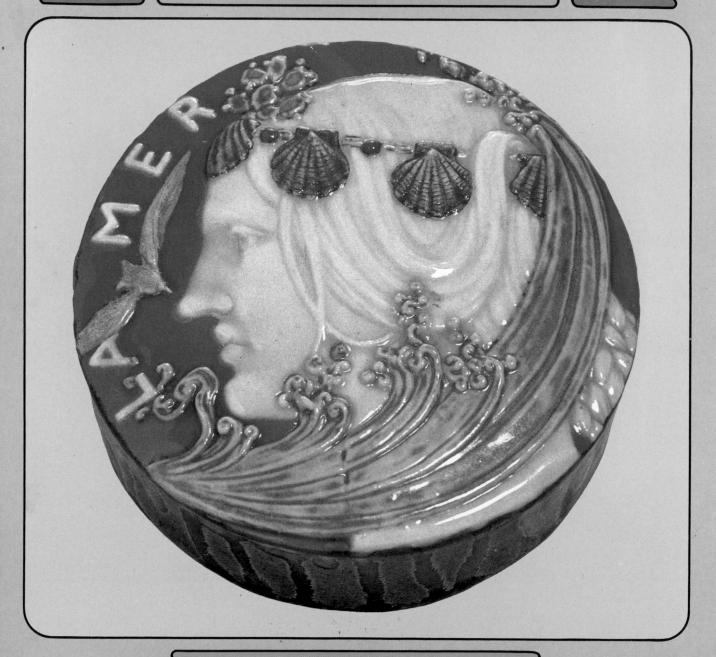

OCTOPUS BOOKS
London

BOUNTY BOOKS
New York

For D.E. In Loving Memory

This edition first published 1974 by
Octopus Books Limited
59 Grosvenor Street, London W1
ISBN 0 7064 0312 6

Published in the USA 1974 by
Bounty Books a division of
Crown Publishers Inc
419 Park Avenue South, NY 10016
Title code 514004

© 1972 Octopus Books Ltd
Produced by Mandarin Publishers Ltd
Printed in Hong Kong

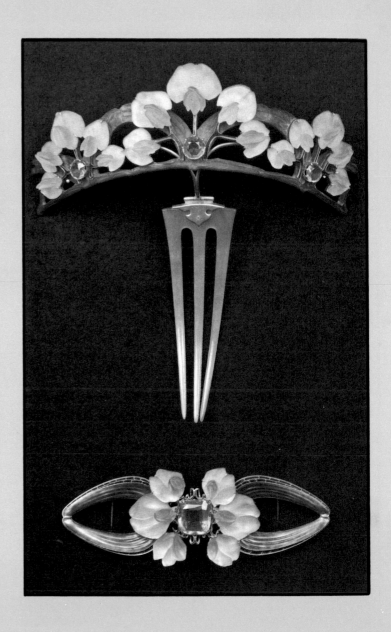

CONTENTS

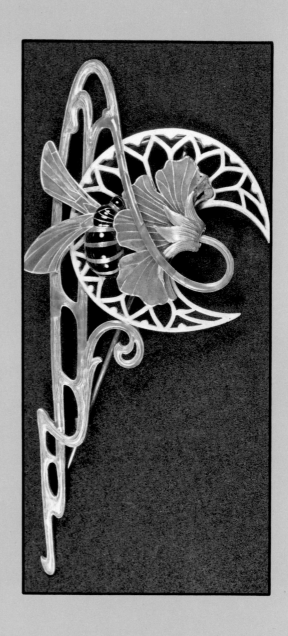

INTRODUCTION

Think of a sensuous line; of a flowing line; a line which bends and turns back on itself. Think of the feminine form, rounded and curving. Think of plant forms growing and burgeoning. Think of flowers in bud, in overblown blossom, as seed pods. Think of lines which seem not to conform; think of waves, think of women's hair; think of twisting smoke. Think too, of controlled lines: lines which begin parallel but then converge and eventually contradict each other. Think of the resulting stress. As the English artist, Walter Crane, one of the earliest exponents of the 'New Art' said in 1889: 'Line is all-important. Let the designer, therefore, in the adaptation of his art, lean upon the staff of line—line determinative, line emphatic, line delicate, line expressive, line controlling and uniting.'

Then think of all this expressed in architecture, rooms, furniture, ceramics, glass, jewellery, the printed page, posters, coffee pots, lamps and cutlery and you will have some idea what Art Nouveau is all about.

But think first of what at the end of the nineteenth century it was *not*. All over that part of the civilized world which had emerged from the Industrial Revolution every upper or middle class home was stuffed with furniture and objects which were copied from Classical, Renaissance, Baroque and Rococo styles. For the most part they were vulgar copies, products of an increasing industrialization, produced for a *nouveau riche* class, which wanted to be reassured that it could afford 'safe', already accepted 'works of art.' Their houses were as affected outside as inside by this desire, as were their town halls, museums, railway stations, and libraries which resembled Greek temples, Renaissance palaces or Gothic churches.

But a reaction was inevitable. Many artists became sick of imitative art and of the machine which seemed to have debased and coarsened everything. They wanted to return to craftsmanship, simplicity and 'nature'. They wanted the products of contemporary civilization to be truly representative of it. As Otto Wagner, a German Architect wrote in 1895, the 'New Style' was to be not a *rebirth*, but a *birth*: modern life alone must be the starting point of artistic creation. This premise was never completely carried out; one must admit that many Art Nouveau artists *did* go back, but in the main they created objects which were valid in themselves and genuinely expressed the age in which they were conceived. The period of this 'New Style' was very short: at its purest, a mere twenty years, from about 1890 to 1910. But for all its brevity, it was one of the most original manifestations of the human creative spirit. Even if one

cannot always applaud it, one must admire its audacity and courage.

But no period of art arrives complete and ready-made. There are always influences working, often centuries back. One can trace Art Nouveau ideas in Celtic, Gothic, Rococco and Japanese art. The Industrial Revolution upset the balance of a natural progression from one art period to another by making reproduction of past forms all too easy. Rumblings of discontent can be traced to writers in the late eighteenth century when the machine began to take over, but it was left to the 1851 Exhibition at the Crystal Palace in London to set off the first blast of real reaction.

Here we discover a paradox. The Crystal Palace, that greenhouse brain-child of the Prince Consort and Joseph Paxton was in itself a revolutionary step. Iron and glass were used to create a simple, startling, functional statement. It looked like a fairy bubble; but it was a bubble which worked. Ironically the contents which it housed, gathered from all over the world, did not measure up to their packing. All the products so proudly displayed were then considered to be in the best 'good taste.' It was left to William Morris, an inspired, far-seeing and socialistic artist, to call it 'tons upon tons of unutterable rubbish.'

Morris is the touchstone for the Art Nouveau movement; yet even he was influenced by the writer John Ruskin and the Pre-Raphaelite painters. Ruskin, hating the machine and the modern world, wanted to retreat to the Middle Ages. In this he was misguided, as were the Pre-Raphaelites, who fondly imagined that they were reproducing the 'pure' Medieval world before Raphael. They believed that only 'nature' was acceptable and on this they turned a microscopic eye. They also hoped, through their art, to reform a materialistic world.

But William Morris went further. Turning his back on the hated machine he preached Art for All, not art as a rare thing which would be produced by only an 'artist'. *Every* man, in his view, was an artist. He had only to return to the Middle Ages, when craftsmanship reigned supreme, to be able to produce objects which were indisputably beautiful.

In 1861, Morris, in collaboration with others, set up the Arts and Crafts Movement. Everything was to be handmade. Furniture, tapestries, wallpapers, fabrics, pottery: all had to be objects of beauty *and* use. The joy of the craftsman in his work would ensure that the work itself was beautiful. And this beauty would immediately be accepted and appreciated by the buyer. Morris wanted art for everyone, just as he wanted education and freedom for everyone.

But he did not realize that hand-made products would be far too expensive for the masses, who, under increasing industrialization were becoming even poorer. He did not appreciate that Victorian society was in no way comparable to the Medieval one. Sincere as he was, his vision was doomed to failure.

But he did set the ball rolling. Without his vision, few of the succeeding Arts and Crafts Societies, the shops, the Arts Centres, the schools, the exhibitions, the magazines and journals, would have happened. One of his most imaginative disciples was Arthur H. Mackmurdo, who founded the Century Guild in 1881. Like Morris, he was typical of the 'new' artist, in that he designed *all* forms of domestic articles. This diversification was to be the outstanding hall-

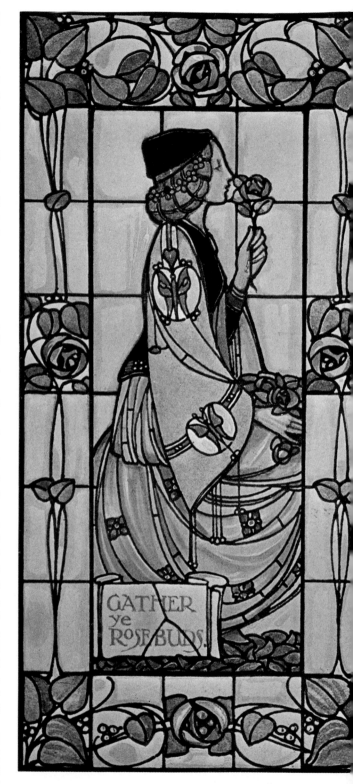

Introduction

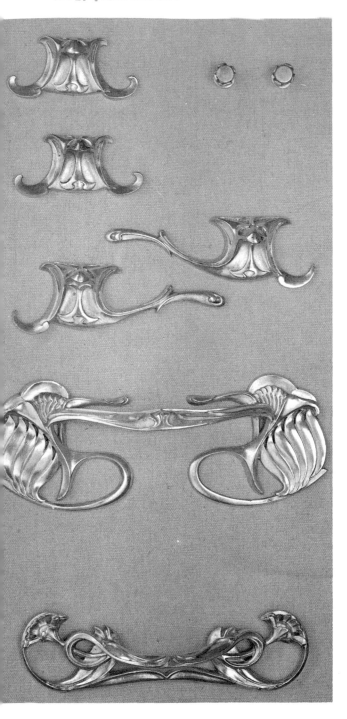

mark of succeeding Art Nouveau artists. There were few who were not able to design a knife and fork with the same fervour, skill and enthusiasm that they put into a building, a piece of furniture or a painting.

Other groups soon followed. Walter Crane, book-designer and illustrator, founded the Art Workers' Guild in 1884. The Arts and Crafts Exhibition Society and the Guild of Handicrafts, the latter inaugurated by C. R. Ashbee, were started in 1899.

For another Art Nouveau influence we must turn to the American painter, James McNeil Whistler. If it had not been for his interest in Japanese Art, this important influence in Art Nouveau might not have been so strong. From the Orient he took its subtle colours, its spare, attenuated line and its masterly use of space. He decorated his own house in Japanese style in 1863 and again 1867. Between 1867 and 1877 he designed the famous peacock room (now in the Freer Gallery of Art, Smithsonian Institution, Washington), inspired by that bird which was to be such a recurring motif for Art Nouveau artists. He also designed a room as a *whole*.

It was this theory of one designer creating a room or an entire house in one style that was one of Art Nouveau's con-tributions to interior decoration. At once a success and a failure, at its best it succeeded; at its worst a whole room, particularly in the most extreme Art Nouveau style, is often too overwhelming and too restless to be lived with. So writh-ing and contorted were some rooms, so overloaded with decoration and design, so constructed out of apparently growing plant forms, that one must have felt in danger of being swallowed up by some enchanted fairy forest.

Because, as with so many revolutions, previous faults were repeated in a different manner, many people soon turned away from Art Nouveau. As a result, few rooms still exist in their entirety.

In 1862 an exhibition of Japanese goods was held in Paris. The whole stand was subsequently bought by an English firm, who put Arthur Lazenby Liberty in charge of their new Oriental department in London. When the firm closed, in 1874, Mr Liberty bought its stock and opened his own shop in Regent Street. Thus the famous firm was born, and thus, due to the fact that Liberty and Co. patronized and en-couraged Art Nouveau artists, the name *Stile Liberty* was given to the movement at one of its stages.

The initial impetus therefore, was English, and its earliest exponent in England was the already mentioned Arthur Mackmurdo. His first Art Nouveau venture was for a chairback, all sweeping curves, which he designed as early as 1881 (see plate 4). He followed it by numerous fabrics, wallpapers and items of furniture. In 1883 he executed a title-page for a book on Christopher Wren's City Churches. Mackmurdo's design had nothing to do with its subject but, like the chairback, it was in Art Nouveau style with its flame-like plant forms, attenuated peacocks and lettering incorporated in the design.

In architecture and furniture Mackmurdo used a narrow vertical line which was to influence such architects as Voysey and Mackintosh. His stylization took natural forms and trans-lated them into abstraction, without losing the original inspiration.

C. R. Ashbee, architect and silversmith (see page *51*), produced the typical English solution to life and art: that of

compromise. Closely allied to the Arts and Crafts movement he was also an important influence on early Art Nouveau.

Charles Annesley Voysey was another English artist at whom the rather unflattering title of 'compromiser' can be levied. Influenced by Japanese art, he excelled in domestic architecture and his houses were particularly successful in their precise proportions, subtle asymmetry and understated ornament. He also used a heart-shaped decorative device— the shape which had a phallic symbolism: the natural concomitant to the female motifs so much used by the whole Movement.

Like prophets, many of these English artists and architects received more recognition abroad than in their own country. Such a one was Hugh Ballie Scott, furniture designer and architect who used Art Nouveau elements as design on flat surfaces rather than on whole pieces (see plate *31*).

Aubrey Beardsley, one of the most famous of English artists has, through recent popularization, become synonymous with Art Nouveau. But we must distinguish between those artists who worked solely from Art Nouveau principles and those who, though using Art Nouveau shapes and motifs, were not actually *of* the Movement. As with Toulouse-Lautrec, Beardsley was a genius in his own right and used Art Nouveau to suit his purpose. His illustrations for Oscar Wilde's *Salome* with their Japanese feeling, stylized women, roses and peacocks are a case in point.

Although it was principally English reaction to the accepted mode, the influence of the Arts and Crafts Movement and like guilds, which persuaded Continental artists also to rebel, little of any importance was later produced in England, although it was kept alive and encouraged by *The Studio* journal and by Liberty in his shop in Regent Street.

Because of his rule that little of the work sold in his shop should be signed it is difficult to attribute English products with certainty. Pewter marked Tubric and silver marked Cymbric came from him; for the rest one has to look for objects which display a certain restraint. On the credit side Liberty made Art Nouveau popular; on the debit, he encouraged poor imitations and unsuitable mass-production.

The journal *The Studio*, with its reports of exhibitions all over Europe gave huge support to Art Nouveau. It also set competitions for a wall-sconce, a fountain or a fire-place. And the amateurs who entered, produced results which are strongly Art Nouveau. This aspect, regrettably, gave the movement a bad name and also hastened its end as a fashionable art form. Professionals cannot bear amateurs!

English designers and artists exhibited their new-found freedom at Brussels in the late 1880's and also in 1892: it was in this year that one of the brightest stars of the Movement, the Belgian architect Victor Norta (1861–1947), began to plan the first important Continental house to be built in Art Nouveau style. This was the Maison Tassel in Brussels. Completed in 1893 it is a watershed of Art Nouveau design, combining as it does both two- and three-dimensional architectural features and decoration. He used wrought-iron in a new way: particularly in the staircase for this house, a poem of fairy-like tendrils, plant forms being his chief source of inspiration. He paid Mackmurdo the com-

Plate 2

Voysey, one of the first English designers to take William Morris's interpretation of Medieval designs one step nearer to Art Nouveau principles, is credited with designing this simple swirling design of teasles, translated in subtle pinks and browns. His designs were less Medieval-inspired than those of Morris, and have a more linear, flat quality.

Introduction

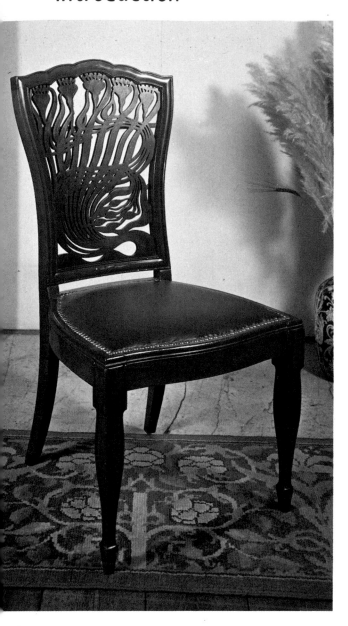

Plate 3

A very important early precursor of the whole Art Nouveau movement, this chair-back by Arthur Heygate Mackmurdo (1851–1942) the English designer, was made as early as 1881. All his designs displayed a completely new concept: a strong sense of rhythm which, taking one direction, would suddenly and dramatically change course, setting up a tension never to be lost in subsequent Art Nouveau design. The chair is an ordinary Victorian one transformed by the pierced and swirly back. Behind it in the photograph are a screen and a carpet by him.

pliment of using one of his wallpapers in this house. Horta designed other important buildings in Brussels: the Hotel van Etvelde in 1898, the Hotel Solvay and the Maison du Peuple in 1895–1900. The latter is remarkable for its façade of iron and glass.

Another Belgian, Henri van de Velde (1863–1957), was not lacking in courage himself in rejecting nineteenth-century cultural pastiche. Starting as a painter he soon displayed an interest in furniture, house decoration, tapestry, silver and jewellery. He strictly followed the tenet that the nature of the material must determine the form and the decoration of whatever subject was involved.

It was from France, pioneer of so many world-affecting art forms, that there came some of the most sophisticated and eccentric manifestations of Art Nouveau. The name of the Movement was finally settled in the French tongue and many of its foremost artists and architects took up the new style. They, of all artists, caught Walter Crane's definition of Art Nouveau as a 'disease' in its most virulent form. Paris, cultural apex of the world, became one of the centres for this newest of crazes and either excelled in it or descended to producing artifacts at their most impractical and bizarre.

The Paris Exhibition of 1900 marked the height of the capital's power and influence; from this moment it reigned supreme in the *Modern Style*, outdoing nearly all others in the way it had always done. Did not the 'Divine' Sarah Bernhardt patronize Mucha and Lalique? Had not Oscar Wilde, most cosmopolitan of writers, written his *Salome* in French? Had not Beardsley, the most French-influenced of English artists, matched the book with perverse and scandalous illustrations? Had not Toulouse-Lautrec elevated the music hall, the stage, prostitutes and lesbians onto the sacred heights of pure art, in his paintings, posters and lithographs?

But not even the French could deny their debt to England and Morris. Not that Paris had the monopoly of French talent: Nancy was also an important centre, producing, among others, such designers as Majorelle, the Daum Brothers and Emile Gallé. It was the latter, who, as early as 1872, visited England and drank from the inspirational fountain of the Arts and Crafts Movement. Equipped with this, his native sensitivity, and expertize inherited from a father who owned a pottery workshop, he set about perfecting a technique of glass making which was strongly to influence the course of Art Nouveau. In this, the design was covered with wax and the remaining areas eaten with acid, which achieved a double surface, both matt and shiny. This glass, with its myriad variations of colour and shading, resulting from cutting, was the very apotheosis of mystery. Greens and yellows, rose and brown, violet and orange: all the variations of smoke from thick to thin, transfigured and illuminated his vases, glasses and jugs.

Not only glass came under his spell: he also designed furniture (see plate 44). Many of his pieces were bone-shaped and he excelled in marquetry and the use of mother-of-pearl.

Another native of Nancy, Louis Majorelle followed Gallé. He worked in the tradition of French furniture design,

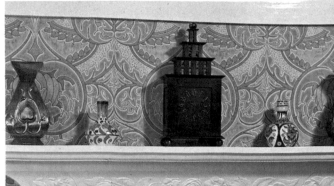

enriching it with his particular contribution of convoluted and twisted Art Nouveau shapes often carried out in gilt and bronze. He made wood and metal suit his whims but he was always the master, never the servant, of his materials.

One of the most famous and most easily recognizable products of Art Nouveau are the Métro entrances in Paris which date from 1900. These were designed by Hector Guimard, one of the most interesting of French architects and designers. He was influenced by Horta but gave his work a special flavour inspired, as was Horta, by plant forms. His first principal architectural venture was the Castel Béranger built in Paris between 1894 and '98. The building boasts a staircase as bold and inventive as Horta's but it is in the iron gateway (see plate 25) that Guimard's genius is shown to full advantage.

In 1895, Samuel Bing, a collector of Japanese art, opened a shop in Paris which he called *La Maison de l'Art Nouveau*. Henri van de Velde is credited with coining the phrase in 1894 but it was Bing's new shop, to which so many artists flocked, that gave the Movement its official title. Bing commissioned an unknown young English artist, Frank Brangwyn, to paint murals for the shop (see plate 85). Following Bing's example many other such shops soon opened in Paris.

Not French but Czech, Alfons Mucha nevertheless found fame in Paris, largely through his posters of Sarah Bernhardt (see plate 95B). He also did work for murals, books, advertisements and magazines, as well as inspiring busts and jewellery.

It is in the realm of jewellery that Art Nouveau holds unquestioned excellence, and it is French designers such as Vever, Fouquet and above all, René Lalique, who produced the best work. Gold, obsidian, pearls, opals, enamel, diamonds, rubies, *plique à jour* and even carved glass were grist to his exotic mill. Myriads of necklaces, brooches, hair ornaments, pendants, combs and pins spun from his fertile brain. He was taken up by Bernhardt, lionized by society and given awards. He used every plant form; every aspect of the peacock; every insect and every strange creature from snake to bat; he rendered women's faces, breasts and hair. He gave solid and glittering form to such soft natural forms as the convolvulus, honesty, sycamore seeds and thistledown.

The Dutch, not very responsive to the Movement, produced some pottery by J. Jurriaan Kok (see plate 54), a building or two and some graphic design but also two important painters, Jan Toorop and Johan Thorn Prikker. They were influenced by the Pre-Raphaelites and Celtic art and idealized women in true Art Nouveau manner. Toorop's women also have a sinister, other-wordly quality in keeping with his quasi-religious themes. He was also inspired by the French Symbolist movement. Prikker, using more stylized, pattern-making techniques, had a fine sense of colour and was also obsessed by religious themes (see plate 84). Both artists show a marked English predilection for literary inspiration.

Norway also produced an artist of great stature: Edvard Munch, who studied in Paris and then spent some years in Berlin where he became the greatest influence

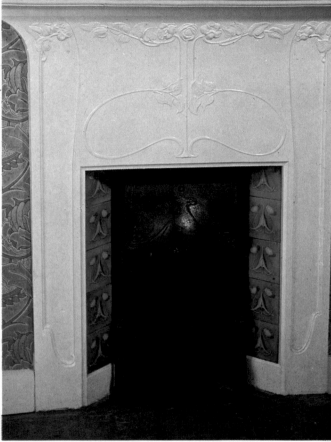

Plate 4

The influence of Art Nouveau soon spread to ordinary domestic architecture and interior decoration, as shown in this simple chimney piece. The fireplace, tiles and woodwork are all decorated with Art Nouveau motifs, which are repeated in the copper and ceramic ornaments, and in the wallpaper designed by Voysey. The clock, also by Voysey, is made of wood and mother-of-pearl and reflects the Mackintosh school.

on German Expressionist painting. In his use of natural forms that reflect man's oneness with, and dependance on, nature, his technique of curved, flowing lines—sometimes violent, sometimes blurred—he is close allied to the Art Nouveau Movement. His paintings reflect his feeling of jealousy, melancholy, anxiety and morbidity and in him one could say that Freud found visual expression (see plate 89).

It is strange that from Scotland, geographically and in many ways culturally, remote from Europe, that there should emerge one of the most interesting and important exponents of the Movement. Largely ignored by England he was nevertheless hailed on the Continent as one of the most important exponents of the New Style. This man was Charles Rennie Mackintosh, architect, furniture designer, painter, jeweller, et al.

Living in Glasgow he founded a famous group: 'The Four', consisting of himself, his wife Margaret, Margaret Macdonald and her sister Frances. This group was acknowledged by the Vienna Sezessionstil and exhibited there in 1897. The group also held an important exhibition at Turin in 1901. Rejecting the florid, over-rich curvilinear motifs common to most of Art Nouveau, Mackintosh and his associates went in for sound structure, simplicity, long straight lines, organized space and such cool colours as white, mauve, green and grey, often dramatically emphasized by black.

Apart from many private houses, Mackintosh designed three buildings which are now most closely connected with his name. All in Glasgow, these are the School of Art, the Willow Tea Rooms and Miss Cranston's Tea Room. Of these, only the Art School remains in its entirety. In it, Mackintosh's main influence was Scottish baronial style, to which he added delicate curving iron-work and soaring windows. In the interiors there is the clever use of contrasting planes and subtle detail. There is even a Cubist interpretation of a Doric capital in the Headmaster's room.

His Willow Tea Rooms was a masterpiece—with its white wooden doors panelled in multi-coloured glass and metal (see plate 32). For these rooms he designed everything: chairs, tables, carpets, light fittings as well as the murals.

He was most appreciated in Vienna where he exhibited interiors at the eighth Sezessionist Exhibition. Austria and Germany had been slow starters in the new Style. But the magazine Jugend gave Art Nouveau one of its other names: Jugendstil. Van de Velde lectured on the new art form at Krefeld in 1895, exhibited his own work at Dresden in 1897 and, when he moved to Berlin in 1899 to live and work, he became an acknowledged leader of the Sezessionists.

In Germany, Hermann Obrist was an artist who practised and propagated Art Nouveau. He designed a revolutionary wall hanging (see plate 5) and went on to ceramics and sculpture, creating abstract whirls and spirals out of stone and clay. Influenced by Tiffany and Gallé, the Germans also turned to glass, and Johann Lötz, with his iridescent and subtle colours most nearly resembled these two masters.

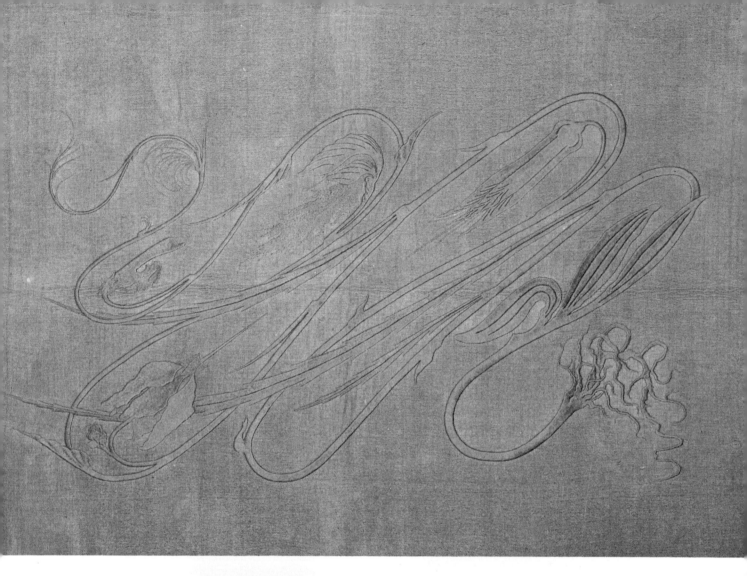

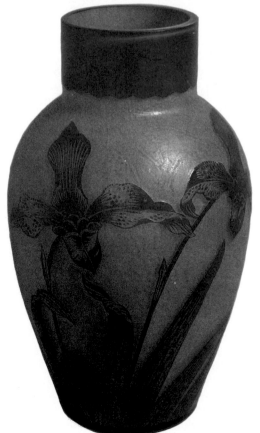

Plate 5

Oﾠne of the most important and famous of all Art Nouveau products, this embroidered wall hanging, *Cyclamen*, was designed by Hermann Obrist (1863–1927) in 1895. The German magazine *Pan* described him as 'exploring the phenomena and forces of nature', and this is shown nowhere more clearly than in this example of which the same magazine wrote: 'Its frantic movement reminds us of the sudden violent curves occasioned by the crack of a whip: now appearing as a forceful outburst of the elements of nature, a stroke of lightning: now, as the defiant signature of a great man, a conqueror.' So apt was this summing up that the hanging is now generally referred to as 'The Whiplash'.

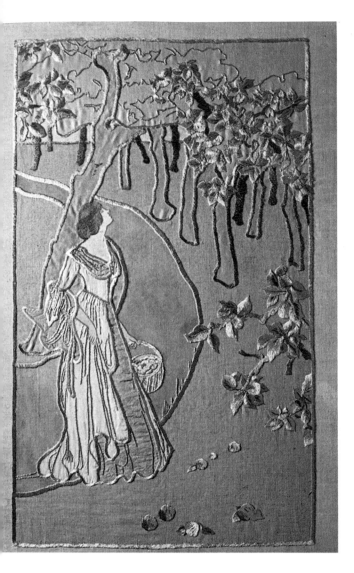

German and Austrian Art Nouveau designers had a tendency towards heaviness; they echoed British, French and Belgian models but usually lacked their delicacy. The Munich architect, August Endel, however, did create facades and interiors which writhed and curved with spindly lightness. One furniture designer to use German heaviness with success was Richard Riemerschmid whose pieces speak strong simplicity (see plate 39), foretelling much work designed later in this century.

Other Austrian architects to be influenced by Mackintosh were Peter Behrens, Josef Hoffman and Otto Wagner who was a leader of Germanic architects during the early years of this century: his Post Office Savings Bank in Vienna being built between 1904 and 1906. These architects, as well as artists, benefited from an imaginative patron, the Grand Duke of Hesse, who in 1901 invited designers to build an artist's colony at Darmstadt. Olbrich designed most of the houses for it, but many of the interiors were by Behrens. Especially notable was the library of his own house and its gentle curves and colours, the simple unity of desk, ceiling and carpet recall Mackintosh. It is easy to see how Behrens, in his turn, influenced such 'twenties and 'thirties architects as Walter Gropius and Le Corbusier.

Joseph Hoffman, who designed the Palais Stoclet in Brussels between 1905–11, which housed Klimt's masterly murals (see plate 87), also designed interiors for houses and exhibitions (whole rooms for exhibitions were a great feature of Art Nouveau) with stencilled wall decoration, tall cabinets and chairs which could almost be taken for those designed by Mackintosh.

Mention has been made of Gustav Klimt, founder member of the Vienna Sezession and one of the most interesting painters of the Movement. In his portraits and murals he usually portrayed women; but whereas most Art Nouveau women tend to be rather sexless, Klimt painted them with a disturbingly sensual reality. At the same time his work was strongly decorative, flat and almost Cubist. In fact, Austrian Art Nouveau's artists' work can be identified by a strong cubist tendency, which owes much to Mackintosh, little to France; see Moser's cabinet (plate 43). Austria's influential and highly successful magazine *Ver Sacrum*, also shows this clearly with its clean marriage of text, borders and illustrations often conceived on variations of the cube (see plate 101).

Most people have heard of Tiffany—his lamps, those stained-glass mushrooms, have become almost an Art Nouveau cliché. Son of a successful New York jeweller who had a branch of his shop in Regent Street, in London, in 1868, the young Tiffany often visited it and it was during this time that he was influenced by Ruskin and Morris.

Back in New York he decorated many houses for the new American rich but it was not until the late 1890's that he began to work with glass in a way which was to make him famous. In 1880 he patented *Favrile* glass, an iridescent technique made by exposing hot glass to a series of metallic fumes and oxides (see plates 13 and 61). Soon it was extremely popular and imitations were produced but never with Tiffany's unique flair and craftsmanship. He produced a vast amount of delicate, exotic and imaginative vases, glasses and

Then Lilies of the day are done,
And sunk the golden westering sun.

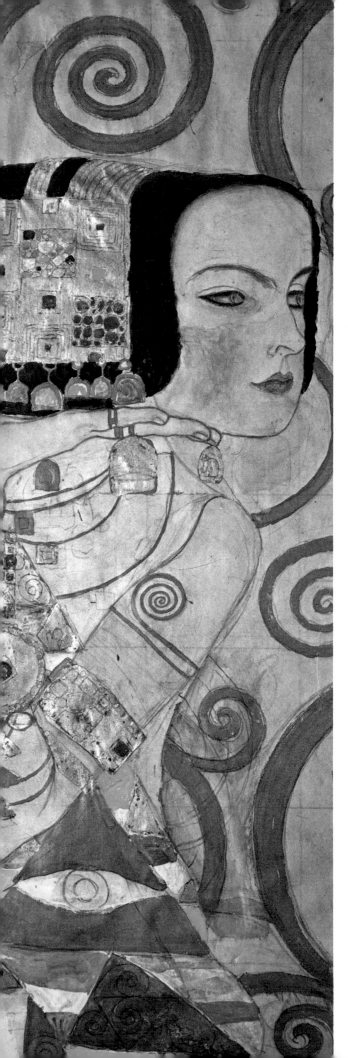

lamps. In 1892 he exhibited a stained-glass window in Europe which guaranteed his influence and fame on the Continent and it was inevitable that the perceptive Samuel Bing should include Tiffany as one of his biggest exhibitors in his new shop. Despite many followers in America, Tiffany remained the only really original Art Nouveau artist in the decorative field that America produced.

But it was left to the architect Louis Sullivan to give American architecture a particularly Art Nouveau look. In the manner of Mackintosh he used light, simple assemblages of lines and curves. He worked with exposed cast iron and his decorative motifs were drawn from Celtic and Byzantine sources. The Bradly residence, completed in 1909, shows Japanese influences: flat areas, simple retilinear shapes and spaces. In this he had some influence on America's greatest architect, Frank Lloyd Wright.

Always out on a limb, individualistic and insular, it was inevitable that the Spanish creative spirit should produce its own brand of Art Nouveau, and produce it in a man of genius: Antoni Gaudí. The curving lines of his Parque Güell and the Casa Milá are waves of the sea arrested in movement, and waves moreover constructed out of a then revolutionary building material—concrete. His wrought-iron was, if anything, even more exotic, as the material lent itself to excess.

Gaudí's extraordinary imagination and strong religious leanings combined to produce his masterpiece, his unfinished Church of the Holy Family in Barcelona. He took full advantage of every architectural trick, every device of simulated movement, for confusing and exciting the eye. Obsessed and consumed by his passion he lived, at the end, a life almost of a hermit and it is sad that he had to leave his life's work incomplete.

Only one other architect ever came near to imitating him and that was the American architect Simon Rodia, himself an eccentric, who, in the 1920's, built a 'Pleasure Dome' or series of towers, constructed out of scrap steel, as fantastic as any spires by Gaudí Rodia even used Gaudí's device of embedding walls with broken tiles and pottery in a crazy, eye-confusing mosaic.

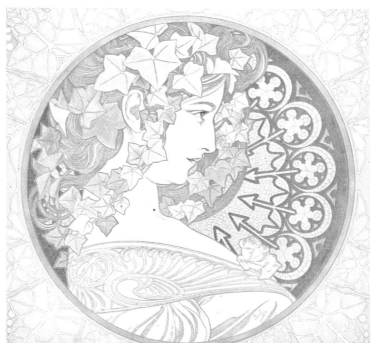

Themes in Art Nouveau

1

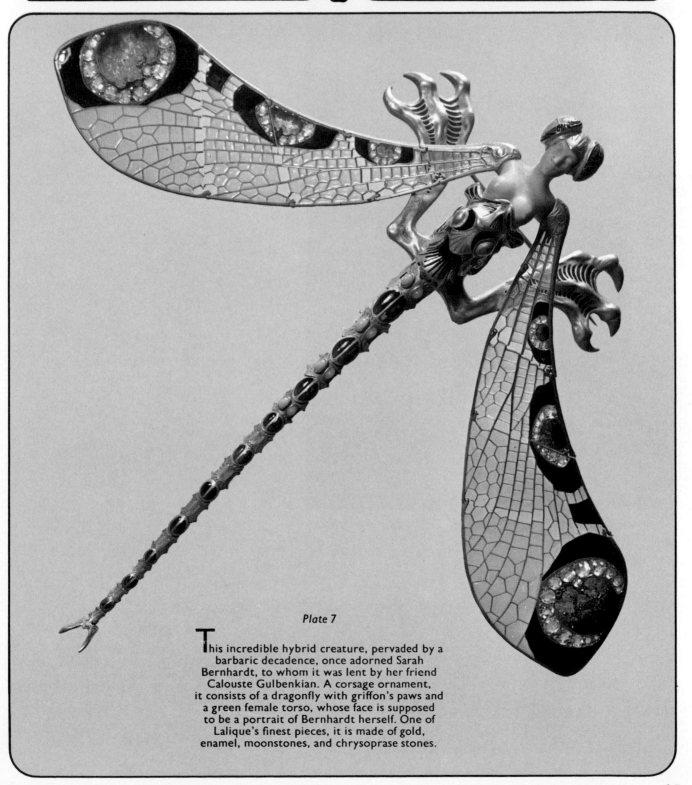

Plate 7

This incredible hybrid creature, pervaded by a barbaric decadence, once adorned Sarah Bernhardt, to whom it was lent by her friend Calouste Gulbenkian. A corsage ornament, it consists of a dragonfly with griffon's paws and a green female torso, whose face is supposed to be a portrait of Bernhardt herself. One of Lalique's finest pieces, it is made of gold, enamel, moonstones, and chrysoprase stones.

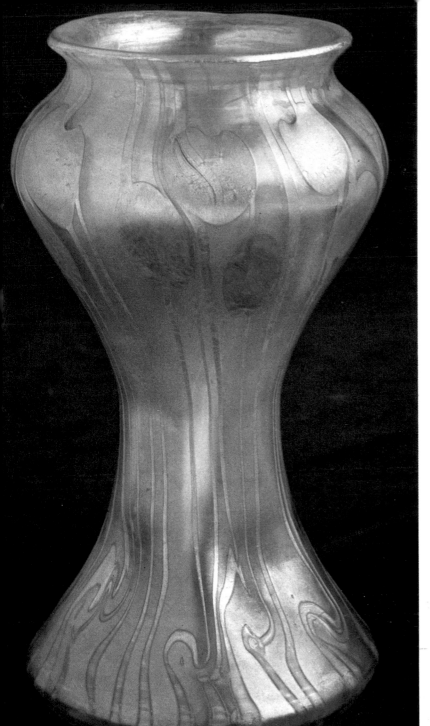

Plate 8

Honesty, a plant with purple flowers and transparent, fragile seed pods, was much beloved by Art Nouveau designers. The pods seemed to possess a fairy-like quality, and were often reproduced as in the example shown here. The pale greeny pods spiral up the side of a silver and gold vase produced at the Loezt factory.

Plate 9

This stained-glass window, bearing the title *Gather Ye Rosebuds*, uses the flower to great stylistic effect, together with a somewhat Pre-Raphaelite girl, sporting butterfly ornament on her sleeves. The window, by Alex Gascoyne, was made in 1906, and was described in *The Studio Book of Decorative Art* for that year as 'suggestive of wholly modern influences'.

8

10

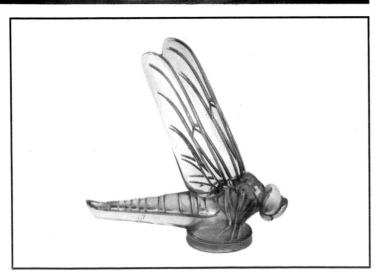

Plate 10

This glass dragonfly by René Lalique is perhaps one of the most remarkable pieces he ever made. It is, in fact, a car mascot designed to be fastened to the bonnet by a bronze base, beneath which was attached a multicoloured lighted disc. Connected to the dynamo of the car, this disc revolved and cast rainbow shades through the insect. The faster the car travelled, the faster the colours changed. A truly fantastic and magical invention, outdoing Rolls-Royce's better-known flying maiden.

9

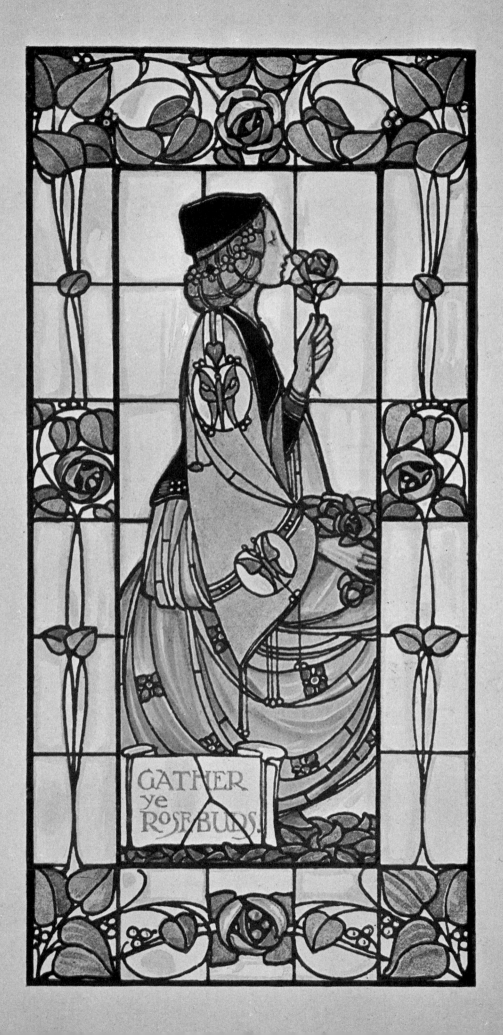

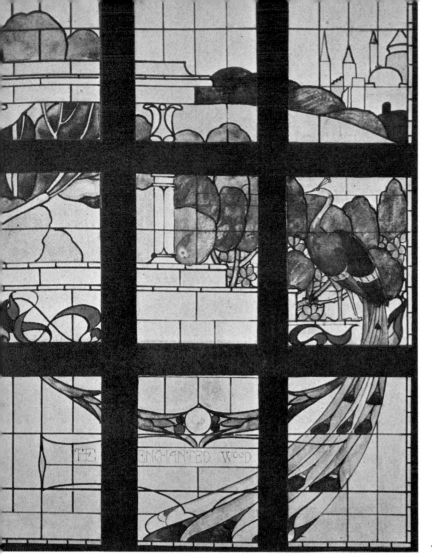

Plate 11

In this stained glass window entitled 'The Enchanted Wood' a peacock stands proudly on a wall surmounted by classical columns, beyond which may be seen the trees of the wood. Designed and executed by the Scottish artist Oscar Paterson, it has that fairy tale quality so often found in many designs of the period. In his windows Paterson specialized in modelling and etching glass with hydrofluoric acid. He often 'fixed' the enamel painting with a thin film of plain glass which, under heat, fused to the painted surface, thus forming a protection for it.

Plate 12

This breathtaking representation of the peacock, in gold, enamel, precious stones and opals, rivals anything created in pen and ink by Aubrey Beardsley. This corsage ornament by René Lalique is particularly interesting for the exquisite naturalistic rendering of the bird itself, contrasted to the highly stylized tail feathers which, with its 'eyes' dramatically picked out in opals, takes the form of a bow.

11

12

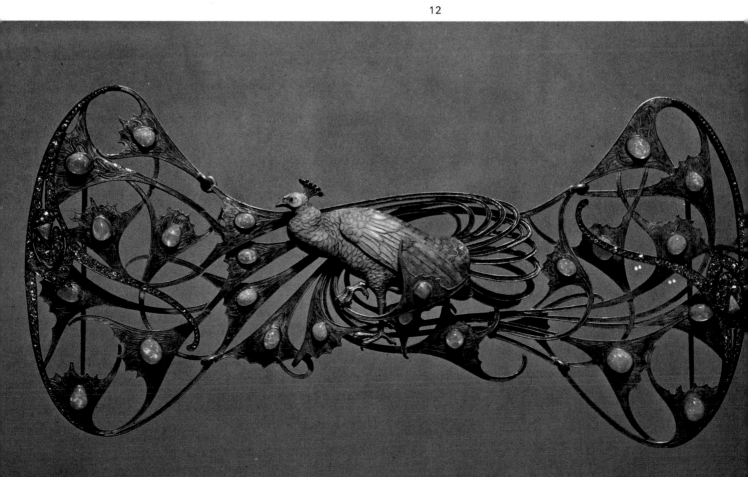

14

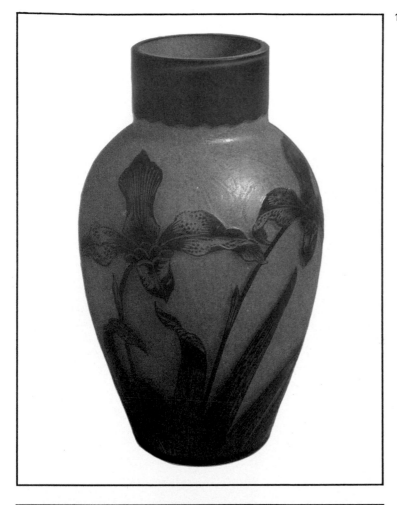

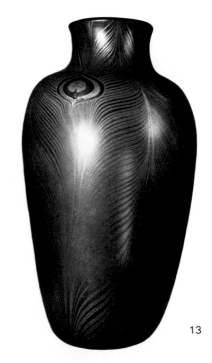

13

Plate 13

This classic vase made of *favrile* glass by Tiffany in 1902, displays another use of the peacock motif. The subtle 'eyes' weave gently up the sides of the vase, and the translucent blues and greens of the bird lend themselves to the properties of this particular type of glass.

Plate 14

This delicate pink vase is decorated by blue irises standing in relief. The effect was achieved by etching away the background with acid before applying the glaze. What could be a rather sickly colour combination has been cleverly avoided by the use of a rather severe, strong blue collar around the rim. The piece was made in France about 1900.

Plate 15

By the time Beardsley came to illustrate Oscar Wilde's *Salome* he was at the height of his creative genius. Much to the author's annoyance the illustrations themselves bear little relation to the actual story, which was used by Beardsley merely as a spring-board for his highly developed, decadent and exotic sense of design. One of the drawings is actually entitled *The Peacock Skirt*, while on the cover shown here, executed in 1907, he again uses the 'eyes' to achieve a fine effect in gold blocking on the green cloth binding.

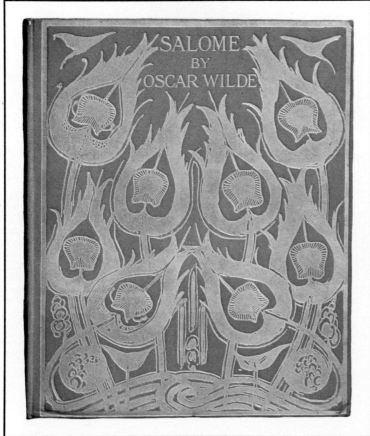

15

Themes

Plate 16

The peacock became almost the symbol for the Art Nouveau movement, following the lead given by Whistler, as early as 1877, in his famous Peacock Room done in 1864. This bird with its exotic appearance, its iridescent colours, its elegant and sinister air, and above all the surrealistic 'eyes' in its tail, was used by Art Nouveau artists in every possible way. The bird on this glazed jug hangs its superb tail down the whole length of the form.

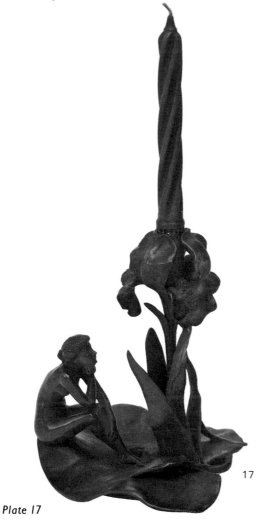

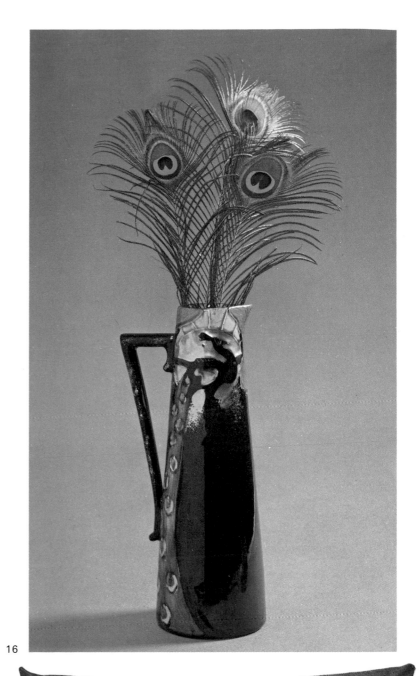

17 16

Plate 17

Throughout the ages candlesticks have lent themselves to every kind of decorative variation. The one shown here, by Jozen, was made for the *Salon des Beaux Arts*, and is in the form of a nymph, sitting upon a water-lily pad, sadly contemplating an iris in full bloom, thrusting its way out of the water.

Plate 18

The rose, a much used Art Nouveau motif, was particularly popular with Beardsley and with Mackintosh and his Scottish followers. One of these, Ann Macbeth, designed and embroidered this cushion cover. It has white roses in chain stitch, appliqué leaves, and a green linen border. During this period many such cushions, table-mats, table runners, and even collars and cuffs were embroidered with designs incorporating such stylized roses.

18

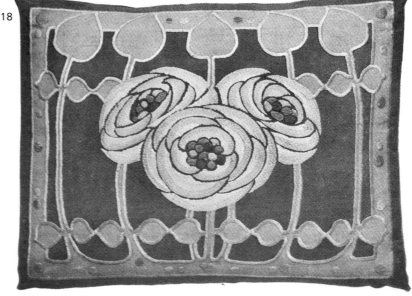

20

Architecture

2

Plate 19

This abstract window of coloured glass is one of many Gaudí designed for his small church of the Colonia Güell (1898–1914), in Barcelona. The Art Nouveau obsession with flowers is taken to its abstract ultimate: glowing, alive and vibrant, it owes little to Medieval origins.

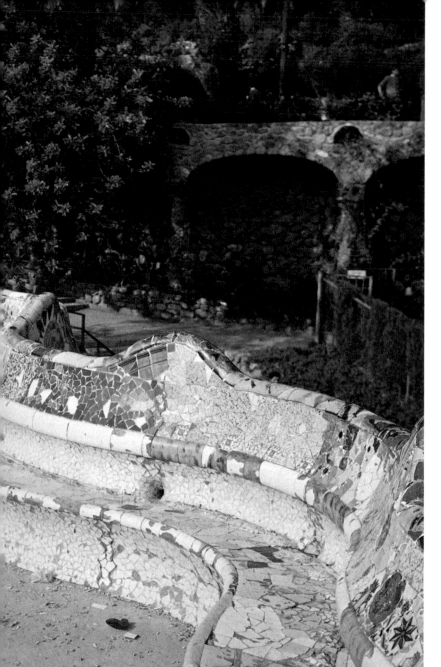

Plate 20

Antoni Gaudí was fortunate in having as his patron a rich Spanish intellectual, Count Don Eusebio Güell, an enthusiastic Wagnerian and a strong Anglophile. For him Gaudí built an extraordinary palace in Barcelona, with cavernous rooms, enormous marble arches, twisting wrought iron, mushrooming brick columns, and mosaic chimney pieces. In the adjoining Parque Güell he created strange structures, including this curious, serpentine bench decorated with his favourite mosaic of tiles, pottery, shards, and pieces of marble, resembling the scaly body of a great snake or lizard.

Plate 21

Petrified waves of the sea; frozen sand dunes; every sea-form comes to mind when one looks at this extraordinary block of flats, the *Casa Milá*, built by Antoni Gaudí in Barcelona, between 1905 and 1910. The marine imagery is even carried out in the seaweed-like wrought-iron balconies and inside on the staircase balustrades. The whole building is as colourless as sand, while what appears to be a curving white band of solidified spray weaves along the roof. No less remarkable are the enormous chimney-pots, more like towers from some exotic fairy-tale than functional objects.

Plate 22

Deeply religious, Gaudí devoted most of his professional life to designing and building one of the most remarkable structures in the history of architecture, namely the Church of The Holy Family, Barcelona. It occupied him from 1909 until his death in 1926 and still remains unfinished. The whole building possesses the fantasy elements of a Hollywood extravaganza. It is all things: Gothic, high Art Nouveau, Expressionist, and Cubist. Rising from a Gothic base encrusted with marine-inspired convoluted forms, four huge hollow and pierced towers soar heavenwards. They resemble attenuated beehives, topped by tiled and convoluted spires which culminate in crosses like rochet wheels. The whole structure sprouts all sorts of gargoyles, including lizards, snakes, salamanders and snails.

20

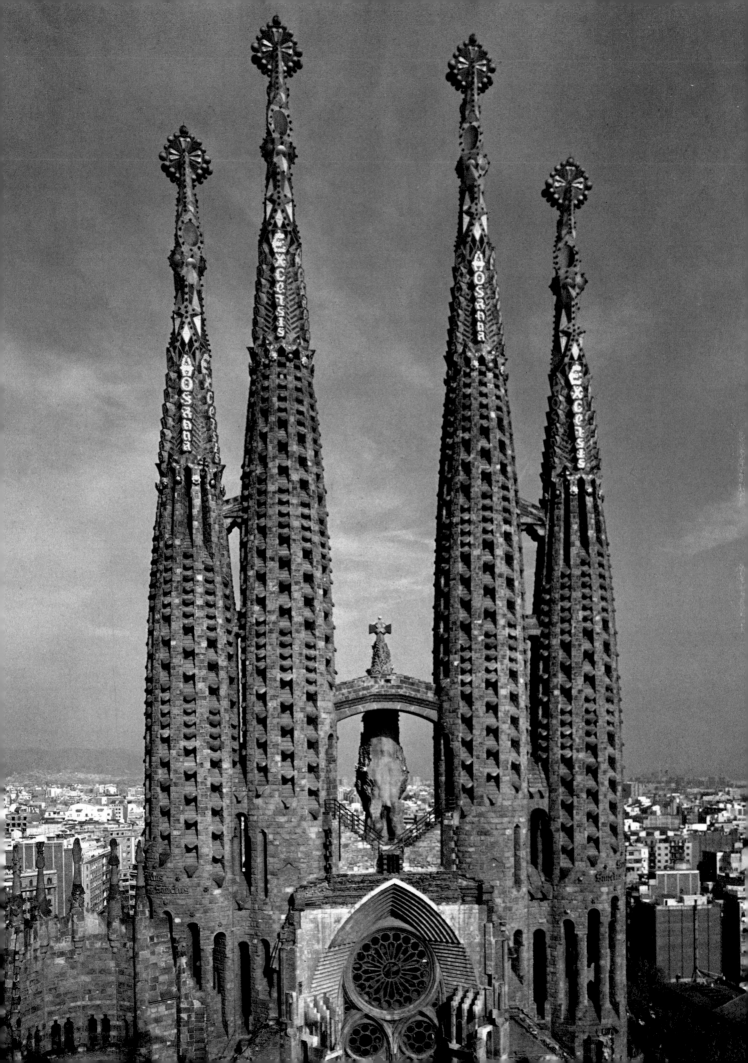

Architecture

Plate 23

Unmistakably Art Nouveau in the organic and restless shape of the huge, bone-shaped windows and unconventional balconies, this elegant apartment house known as the *Casa Batlló* was built by Gaudí during 1905 to 1907. Inside none of the rooms is square, and the walls and ceilings appear to be in movement.

Plate 24

Designed as late as 1911, this curving staircase, from a house in the Avenue Mozart, Paris, with its sinuous wrought-iron stair rail, is representative of Hector Guimard's best work. He was responsible for the entire appearance of this hallway, including the lamp hangings and window frames. Similar ironwork by him was made for the Castel Béranger in Paris, which he began in 1894 and completed in 1898.

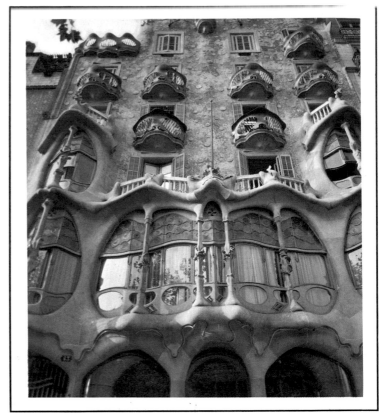

23

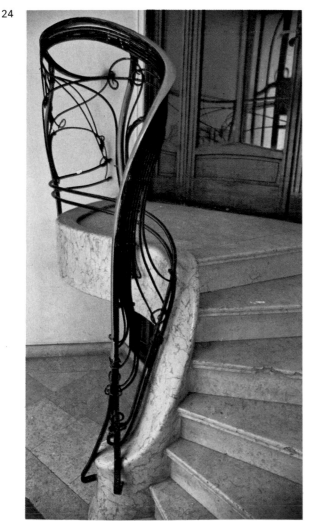

24

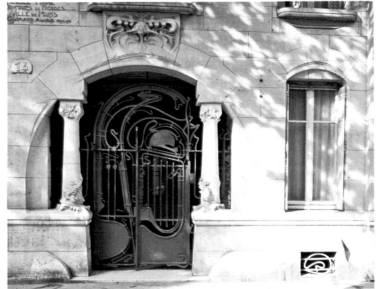

25

Plate 25

The Castel Béranger in Paris is one of Hector Guimard's most important architectural achievements. Every detail bears his stamp. Even the grills covering the vents have been carefully designed. Although the stonework here is more restrained, the wrought-iron gate embodies curved and straight lines, upright and horizontal forms, all caught in a cleverly realized tension, which is one of the characteristics of successful Art Nouveau.

Plate 26

April is the cruellest month, breeding lilacs out of the dead land.' So wrote T. S. Eliot. The dead pavements of Paris apparently bred green iron plants, burgeoning with buds, like mysterious overgrown cave-mouths. These are the famous Métro entrances, designed by Hector Guimard in 1900. Alas, not many of them are now left, but one has found its way to the Museum of Modern Art in New York. They show Guimard at his most fanciful, inspired by plant forms, utilized for a functional and mundane purpose.

B. An interesting view of one of the entrances from below: through a stained-glass window one can see the plant-inspired railing.

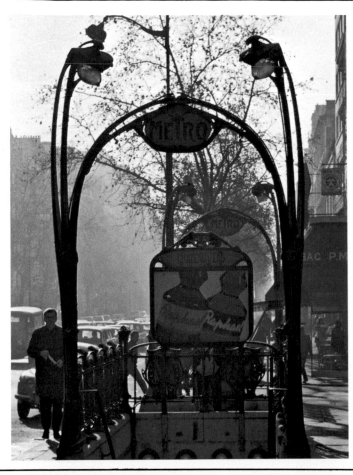

26A

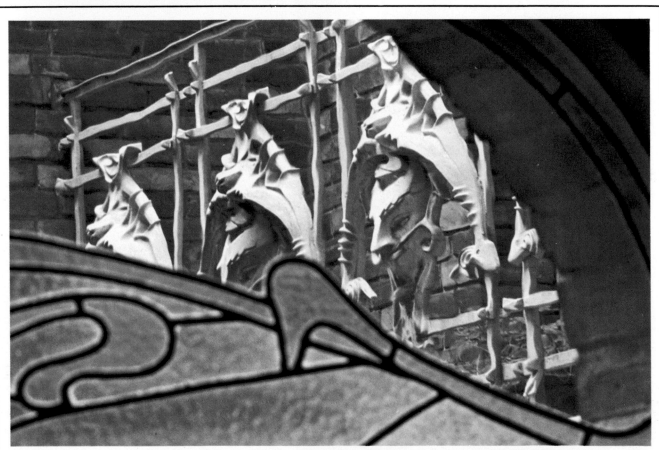

26B

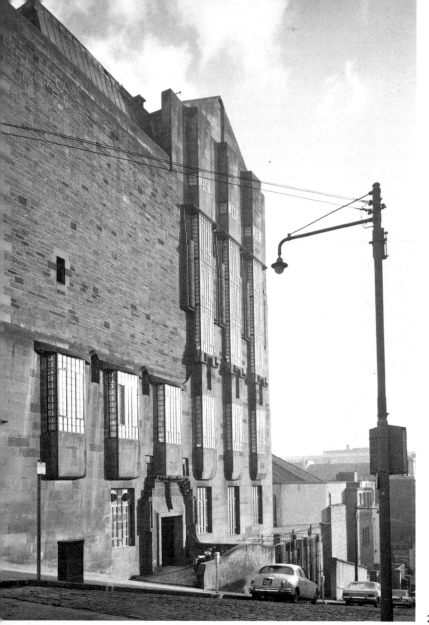

Plate 27

Mackintosh's Glasgow School of Art stands out as an important landmark in the history of architecture, and Art Nouveau in particular. Mackintosh, already a practising architect, was successful in winning a competition for the design, although contemporary Scottish opinion considered that his conception was too advanced for the time. The first part of the building was erected between 1897 and 1899, while the second part, the west façade of which is shown here, contains the library and is considered the more successful. It was built between 1907 and 1909. Based on the Scottish baronial style, Mackintosh added his own version of attenuated bay windows. The low doorway with its heavy architrave makes a clever contrast to the soaring elegance of stone and glass above.

27

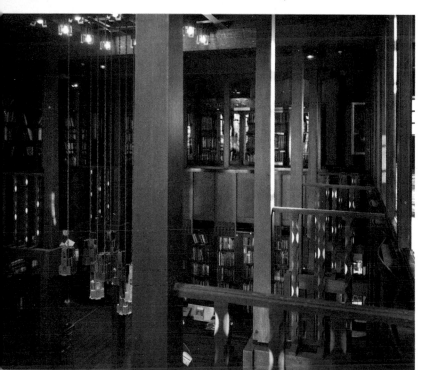

Plate 28

The interior of the library repeats the soaring lines of its windows. Tall square pillars of stained pine rise seventeen feet from the floor to carry a coffered ceiling. The construction of the galleries was deliberately left exposed, as in a medieval cathedral or church and in many American Art Nouveau buildings. The narrow supports, decorated with brightly coloured facets, are in contrast to the bare main structural columns. Mackintosh even designed the bookcases, tables, chairs, and magazine racks, leaving nothing untouched by his unique sense of design.

28

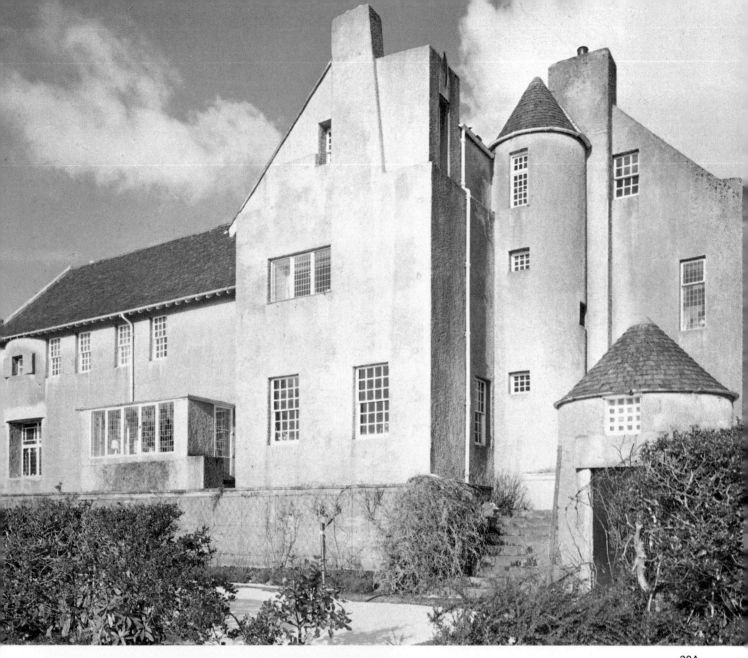

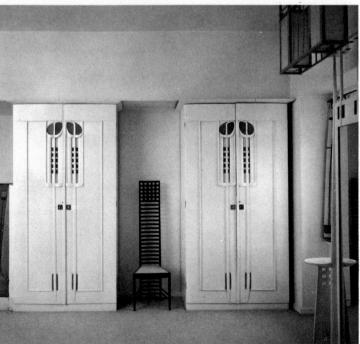

Plate 29A, B

Mackintosh designed Hill House (A) in Helensburgh, Scotland, in 1902, for the publisher W. W. Blackie. One of many he designed, it is based on a traditional L-shaped plan, and reflects the traditional Scottish baronial style with its turrets, gable roofs, and small, rhythmically placed windows. Inside the house (B) he was able to carry out his usual scheme of organized space, white walls and delicate, attenuated furniture, subtly patterned in black and pastel colours.

29B

Architecture

Plate 30

This Paris doorway provides a first-class example of the French Art Nouveau style. In contrast to Mackintosh's sober, almost austere, designs, this is incredibly unrestrained and exotic. Asymmetric in conception, it is based on sinuous plant forms which sweep around the entrance, bursting into bloom above it.

Plate 31

This design for a music room was made by the English architect M. H. Baillie Scott in 1902. With Mackintosh he shared a preference for simple, straight lines, square forms and stencilled decoration. Its greens, pinks and yellows resemble a Post-Impressionist palette. Reflecting his interest in peasant art, it is in complete contrast to contemporary work being done in Paris and Barcelona. Baillie Scott was much admired in both Germany and Switzerland, and designed houses in Poland and Russia.

Plate 32

A *pièce de resistance* of Art Nouveau and of the Scottish movement, these white wood, stained-glass and leaded doors are all that are left of the famous Willow Tea Rooms in Sauchiehall Street, Glasgow, which Mackintosh designed for Miss Cranston, who must have been one of the most advanced of all 'tea shoppe' ladies. Carrying out the theme of the willow, Mackintosh deliberately attempted to convey the idea of a forest in the teashop by suggesting slender tree trunks in the use of white columns round the walls. These doors, apart from the skilful use of stained glass and lead, are remarkable for the fact that they are set in a narrow, unmoulded architrave.

30

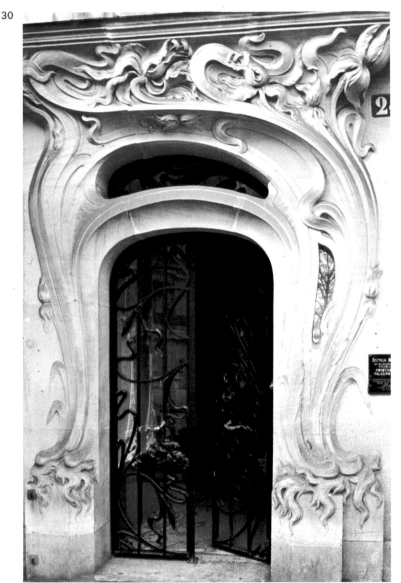

31

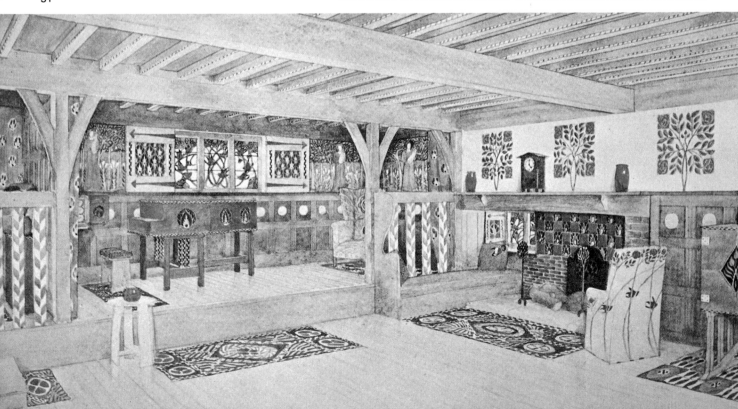

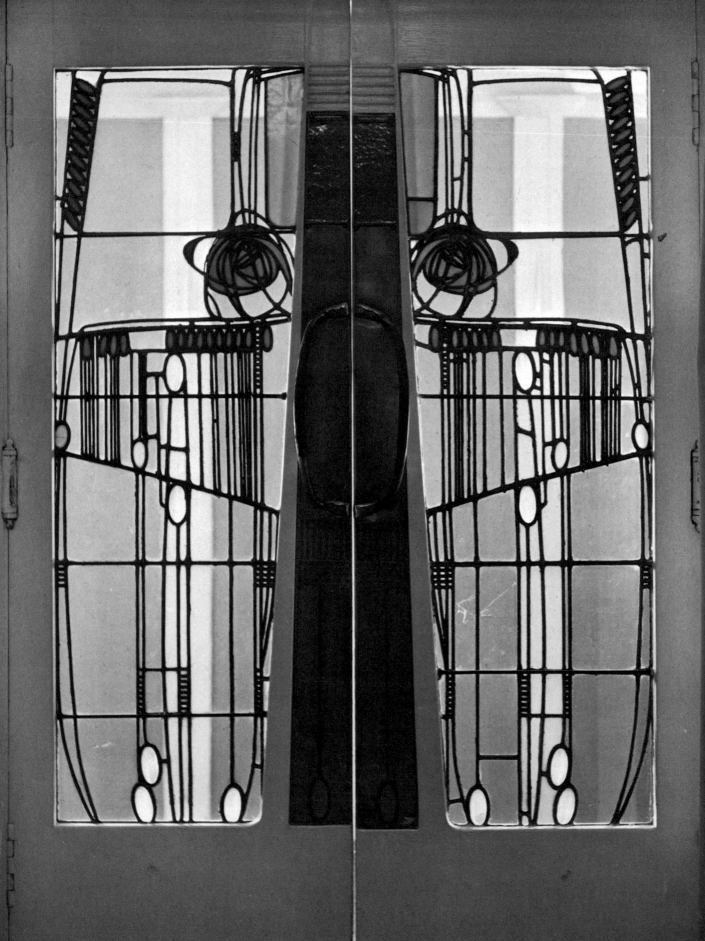

Furniture

3

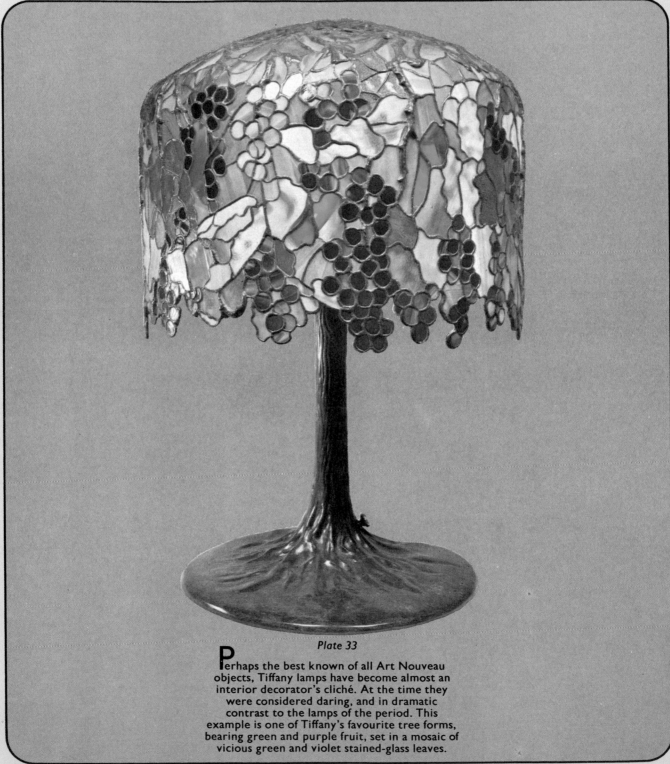

Plate 33

Perhaps the best known of all Art Nouveau objects, Tiffany lamps have become almost an interior decorator's cliché. At the time they were considered daring, and in dramatic contrast to the lamps of the period. This example is one of Tiffany's favourite tree forms, bearing green and purple fruit, set in a mosaic of vicious green and violet stained-glass leaves.

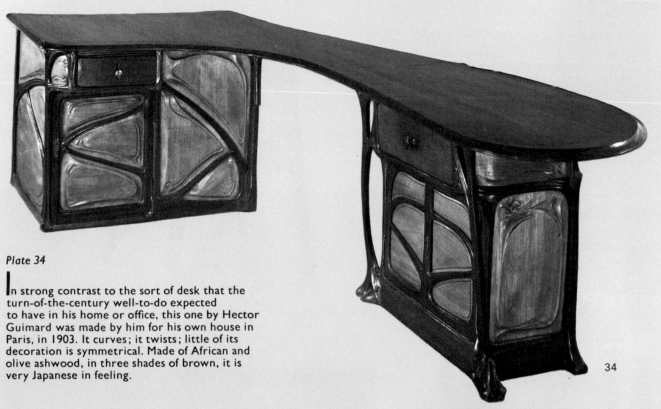

Plate 34

In strong contrast to the sort of desk that the turn-of-the-century well-to-do expected to have in his home or office, this one by Hector Guimard was made by him for his own house in Paris, in 1903. It curves; it twists; little of its decoration is symmetrical. Made of African and olive ashwood, in three shades of brown, it is very Japanese in feeling.

34

36

Plate 35

By an unknown English craftsman, and almost certainly from Liberty, this oak dresser, with copper fittings, is a beautiful example of the restrained yet decorative English style, owing much to William Morris and the Arts and Crafts movement. The ornaments are either English or French.

35

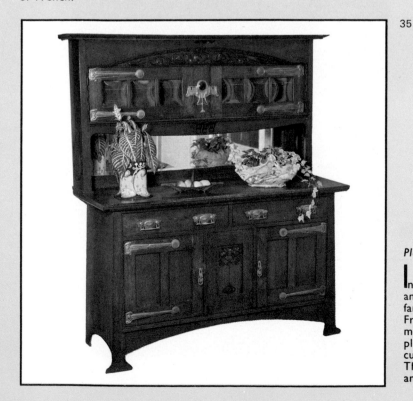

Plate 36

In marquetry and various woods this cabinet, by an anonymous French designer, displays the fanciful, erratic qualities often to be found in French Art Nouveau. Spindly brass fittings and motifs climb and grow over the surface like plants, and the soaring top shelf echoes, in a curved form, Mackmurdo's 'mortar board' tops. The vases and jugs in the cabinet are Italian and Hungarian.

Furniture

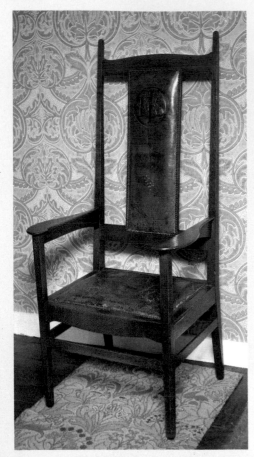

37

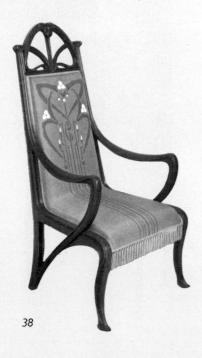

38

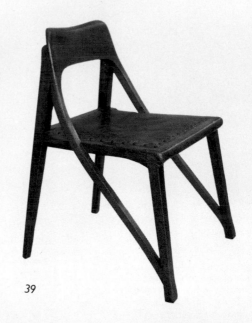

39

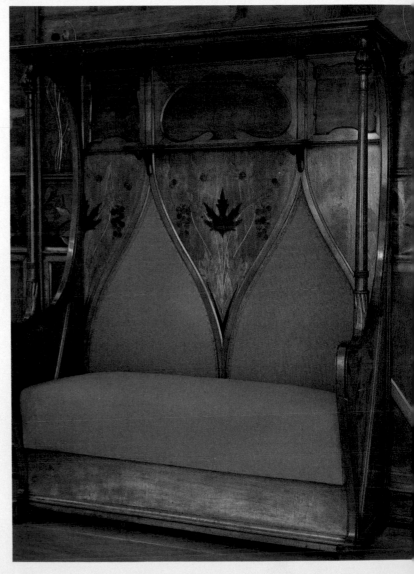

40

32

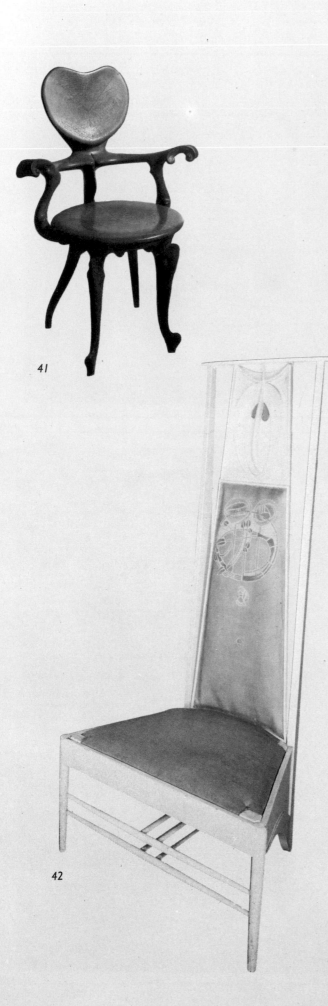

41

42

Plate 37

Strongly influenced by Mackmurdo, Charles Francis Annesley Voysey (1857–1941) was one of the leading architect-designers of the English Art Nouveau movement. He specialized in building small country houses based on Medieval traditional designs, which were reflected in the fabrics, wallpapers (see plate 2) and furniture he produced to go in them. Simple as it is, upholstered in leather and embossed with a cypher, this oak armchair betrays Medieval influence, as do the wallpaper and the carpet on which the chair stands, which are also by Voysey.

Plate 38

This graceful armchair by Louis Majorelle (1859–1926) was made in about 1900. It owes less to Majorelle's usual French classic inspiration than many of his pieces of furniture. One can sense the original impetus but the shapes, particularly those employed at the back of the chair, are pure Art Nouveau—as is the design on the fabric, which is a modern copy.

Plate 39

One of the most 'classical' of Art Nouveau designers, the German Richard Riemerschmid (1868–1957), eschewed the luxuriant flow and ripple of much Art Nouveau work. His ideas have strongly influenced furniture design up to the present day. This restrainedly elegant chair, made in oak and upholstered in leather, was made for the music room which he contributed to the Dresden Exhibition of Decorative Arts in 1899.

Plate 40

This settle and part of a panelled wall are all that is left of a music room designed by Carl Spindler and made by the cabinet maker J. J. Graf, both Austrians. Made of walnut with marquetry of pearwood, tulipwood, maple, amboyna and other woods, this settle was part of a prize-winning room carried out entirely in the same manner, for the Paris Exhibition of 1900. All the walls showed pastoral scenes in marquetry: the piano sported inlaid leaves; a table was comparatively simple and a glass-fronted cabinet echoed, in reverse form, the ogee shapes on the settle.

Plate 41

This chair by Antonio Gaudí is from a set of six which he made for the boardroom in the Casa Calvet, Barcelona. Bone-line and organic, it resembles driftwood rubbed smooth by endless tides.

Plate 42

This white, painted chair formed part of Charles and Margaret Mackintosh's contribution to the International Exhibition of Modern Decorative Art held in Turin in 1902. It came from the 'Rose Boudoir', one of the three rooms which formed the Scottish entry. The colours of the Rose Boudoir were of pearly lightness: white, pale rose, violet, green and blue.

Furniture

Plate 43

Although better known for his book designs and decorative work, Kolo Moser also turned his hand to furniture design. This cupboard is part of a suite made by him for a living room. Like so much Austrian work of this period, it is strongly influenced by Mackintosh, although the glittering and mosaic central panel reflects the style of the Austrian painter Gustav Klimt. Two portrait panels in bas-relief break up the starkness of the cupboard doors, while metal columns give to the whole a classic look.

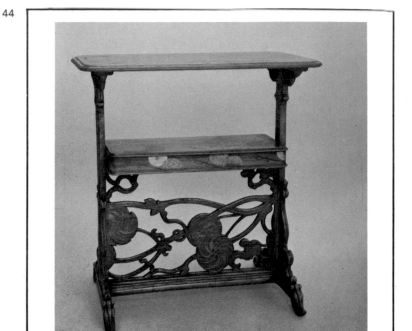

44

43

Plate 44

Signed *Chez Gallé*, this worktable of carved ash, with marquetry and overlays of other woods, shows how Gallé decorated a simple form with highly stylized leaves and stems. Bearing the inscription, in French, 'Work is Joy' it demonstrates the designer's fondness for including moral or poetic phrases in his work.

Plate 45

This cabinet by Louis Majorelle, of about 1900, combines many woods: walnut and oak, coramandel and burr-walnut, all carved, curved, pierced and used as veneer. The picture on the panel at the top shows a seagull flying over a cliff, and the elaborate plant-shaped hinges are of wrought iron. This and the work table by Gallé (see plate 44) received much criticism when they were first exhibited in England.

Plate 46

Like so many Art Nouveau artists, George de Feure was interested in every aspect of design, and made this set of fittings for a suite of bedroom furniture. Finely conceived and modelled on plant forms, they are beautiful interpretations of utilitarian objects.

45

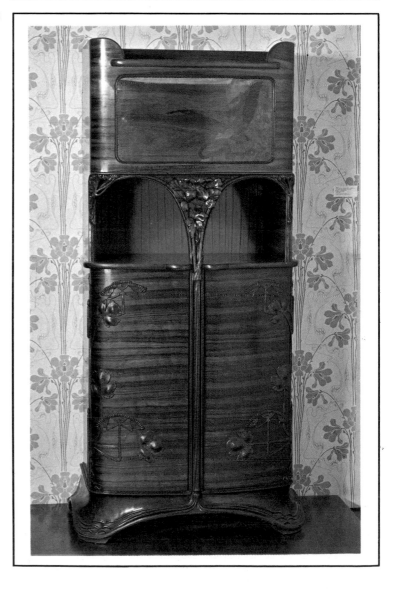

Furniture

Plate 47A, B

These two clocks display contrasting styles of Art Nouveau. The superb bronze one (A) is, surprisingly, unsigned, but is almost certainly French. Phallic in shape, it is surmounted by the head and shoulders of a woman bearing a headdress of poppies, while its base is composed of swirling leaves or drapery. The sombre bronze is relieved by the turquoise centres of the poppies. The gilded clock (B) has been conceived in a marked asymmetrical form, and although strongly curved it achieves perfect balance. It is also unsigned, and is probably French. A young girl and a cluster of irises support the clock face, which is modern.

Plate 48

One of the first examples of the female form being used as part of an electric lamp, this bronze piece was designed by H. Beau in the 1890s. As a lamp it is not particularly successful, the bulbs being too small and pale, as to be only decorative adjuncts to the main purpose of the exercise: that of displaying a woman and a plant in a fanciful, fairy-tale manner. She rises from the leaves, her feet peeping provocatively through the foliage.

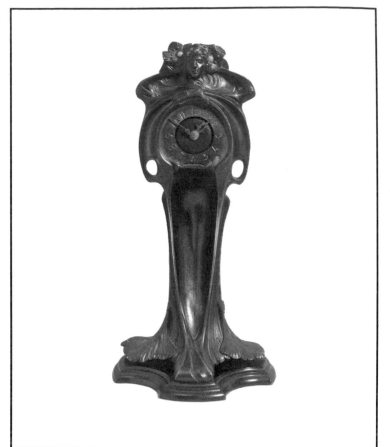

47A

47B

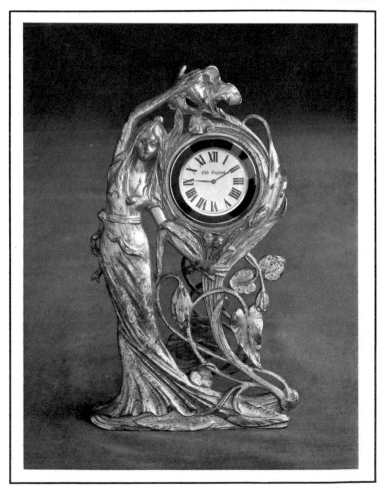

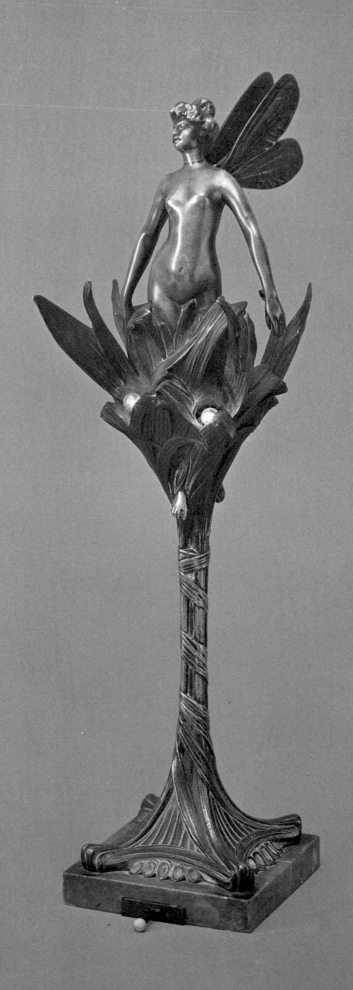

Furniture

Plate 49 A, B

Both these beautiful standing mirrors employ the sloped, converging lines so characteristic of Art Nouveau. But whereas the Continental mahogany one (A) is decorated with plant forms and a woman's head in pewter to give it interest, (B) relies entirely on its elegant lines, both straight and curved, to achieve a perfectly balanced effect. It shows the strong influence of Mackintosh, and may even be by him.

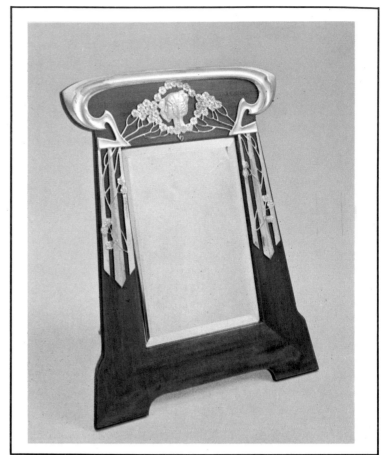

49A

49B

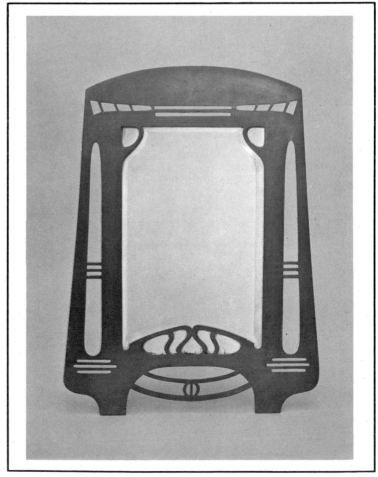

38

Ceramics

4

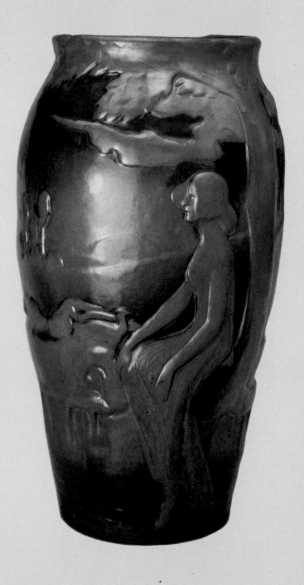

Plate 50

The story of the Goose Girl by the Brothers
Grimm was the inspiration for this vase made in
1900 by the Hungarian potter W. Zsolnay Pečs.
It is of grey earthenware, decorated in low relief,
and enhanced by a particularly beautiful
combination of coloured lustres. The whole piece
is mysterious and translucent, echoing the gold
and blue-green plummage of the peacock.

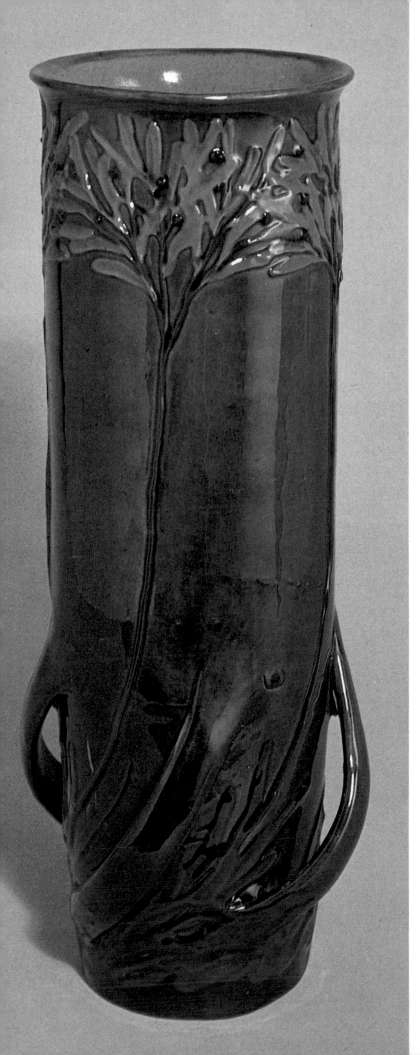

Plate 51

Bladderwrack seaweed forms the decoration on this highly glazed earthenware vase by Max Laeuger. Made in 1900, the low-placed 'handles' are characteristically Art Nouveau and add to the overall feeling of marine growth.

Plate 52

Wind-blown flowers bend around the sides of this vase created by Max Laeuger (1864–1952). Although he was primarily an architect he also specialized in ceramics. As with many artists in pottery at this time, he based his designs on Oriental patterns. This vase dating from 1898 is made of earthenware with relief slip decoration, and the whole covered with stained glazes. Laeuger exhibited in Munich in 1908 at the first Comprehensive Art Nouveau exhibition in Germany.

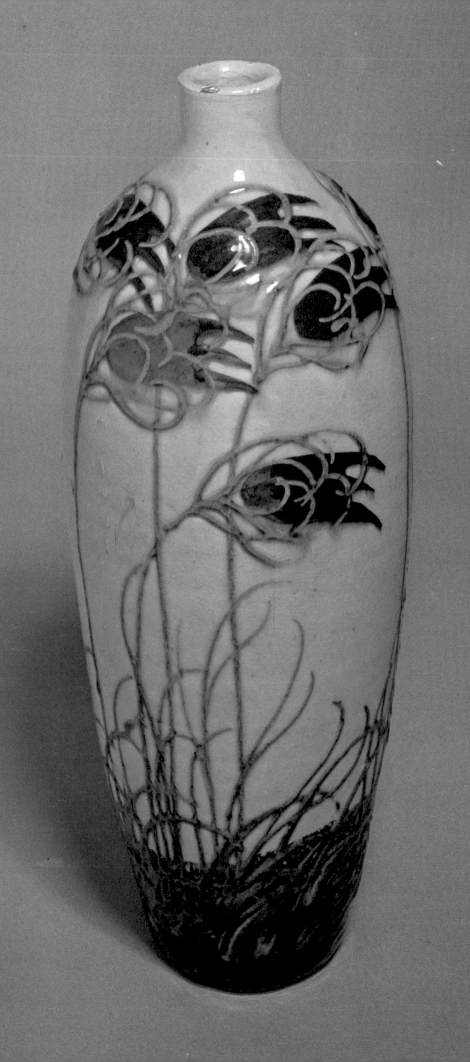

Ceramics

Plate 53

It was not only in the field of fine art that Art Nouveau found its expression; all manner of everyday items were designed and decorated in its style. Although appearing at first to be in the blue and white tradition of Chinese or Dutch porcelain, this English cheese dish bears an unmistakable Art Nouveau shape and decoration. The handle is particularly interesting, repeating the curling tendril design on the side.

Plate 54

In the decorative arts Holland did not produce much in the Art Nouveau style. One exception, however, was J. Jurriaan Kok, who worked for the Royal Rozenburg Porcelain works at The Hague. These subtly decorated eggshell porcelain pieces dated about 1901 have almost a Mackintosh flavour in their soft colours and display the fairy-tale aspect of Art Nouveau at its most pleasing.

Plate 55

These pieces from a tea and coffee service were designed by Henri van de Velde for the Royal Meissen factory. The decoration flows naturally and simply from the very forms themselves, giving a wholly satisfying result.

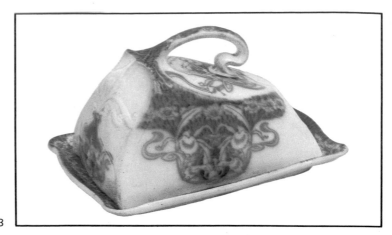

53

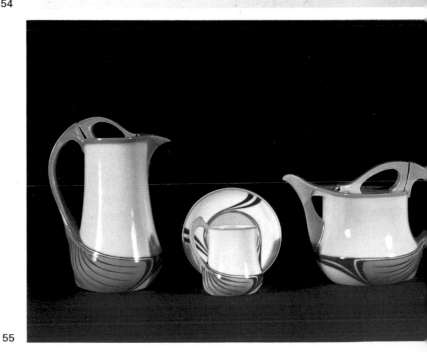

54

55

42

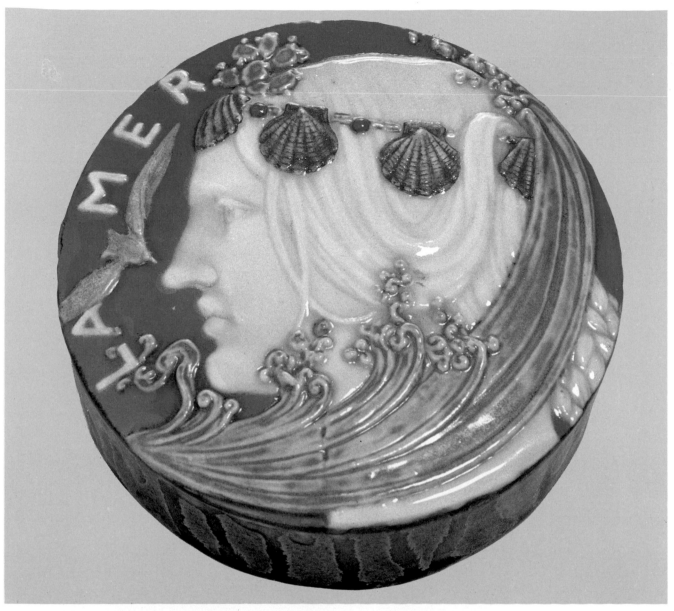

56

57

Plate 56

Possibly a paperweight, this hard porcelain plaque shows a skilful and lovely interpretation of a woman's head supported by oceanic motifs. It may have been one of a set portraying the elements. Ornamented with paste decoration and coloured glazes, it comes from the Sèvres factory and was made in 1901 by Taxile Doat.

Plate 57

There must still be in existence hundreds of fireplaces, bathrooms, hallways and staircases decorated with tiles bearing Art Nouveau motifs. Those shown here are typical, and were probably designed to make a frieze or a continuous upright panel.

Glass

5

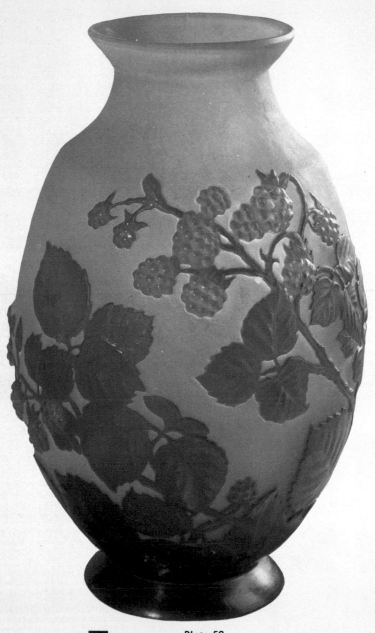

Plate 58

This is a typical example of Emile Gallé's 'blown-moulded' glass, employing naturalistic raspberries in a wide range of yellows, reds and browns. In the technique employed a vase was first sculptured in wax, from which a mould was made. Molten glass was then blown into this mould and decorated with colour. All kinds of fruit lent themselves to this particular treatment.

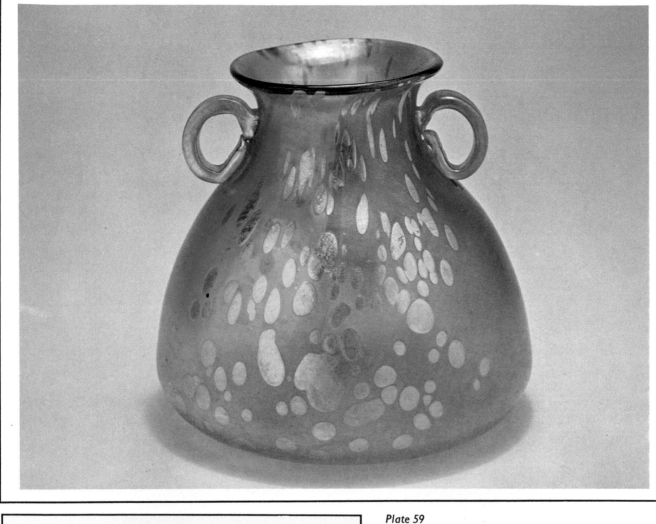

59

60

Plate 59

This green and pink, two-handled vase, mottled with subtle water-drop-like blobs of gold was made by Johann Witeve Lötz. A follower of Tiffany, he ran a glass factory in Klostermuhle in Austria and worked from the late 1890's into the early years of this century. Like his master he was skilful in the use of iridescent effects as well as employing overlay and a cameo technique.

Plate 60

This exquisite glass figure made for the Daum factory, and modelled by Almeric Walter of Nancy in about 1902, embodies that mystery and veiled sensuality with which so many Art Nouveau artists endowed the female form. It is made of *paté de verre*, which is glass ground into a fine powder, mixed with liquid, usually plain water, and then baked in a mould.

61B

Probably made in England, the unsigned myriad green glass vase trapped, as it were, in a cage of pewter tendrils which loop up to form two handles above the rim (A). Its broad treatment provides an interesting contrast to the slender, classically restrained, green glass vase supported on a bronze tripod (B), by the Austrian artist Professor Bakalowitz who worked for the firm of E. Bakalowitz and Sönne of Vienna.

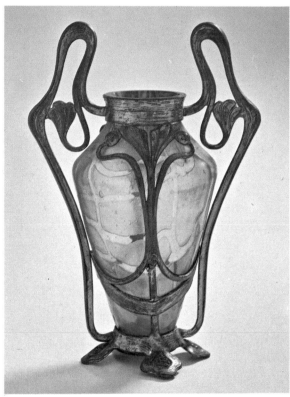

61A

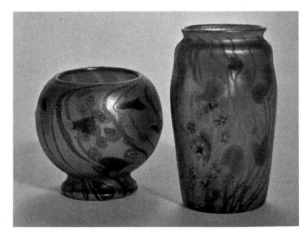

62

Plate 62

These two delicate vases made in 1902 in *favrile* glass, display Tiffany's particular contribution in the realms of iridescent technique. He was as much fascinated by this aspect as by the actual design. He noticed that glass buried for centuries acquired a glow due to erosion and exposure to mineral salts, and he succeeded in achieving this effect by mechanical means.

Plate 63

This pitcher from the factory run by the Daum
brothers is considered one of their masterpieces.
It is entirely wheelcast, with an appliqué handle
and displays a fine harmony of softly blended
colours like a forest glade seen through an
autumn mist.

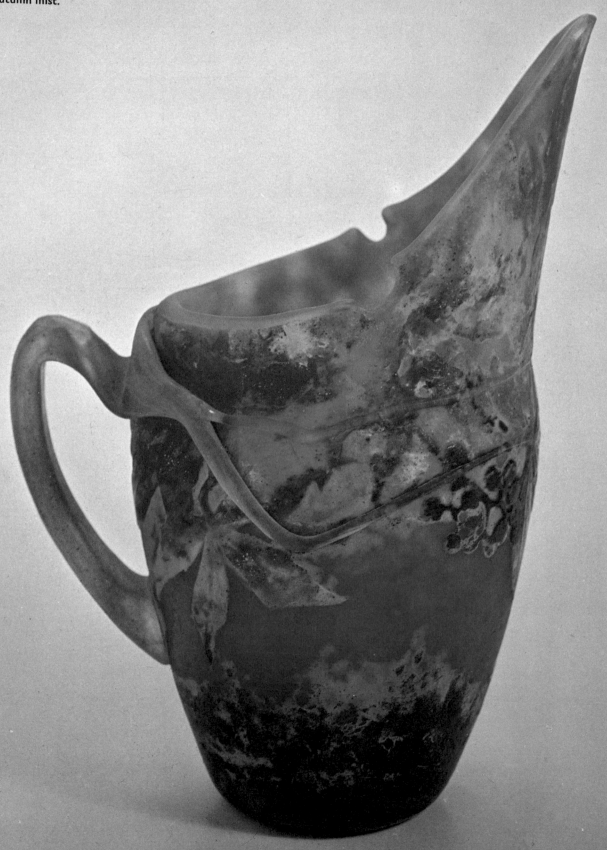

Fine Metalwork

6

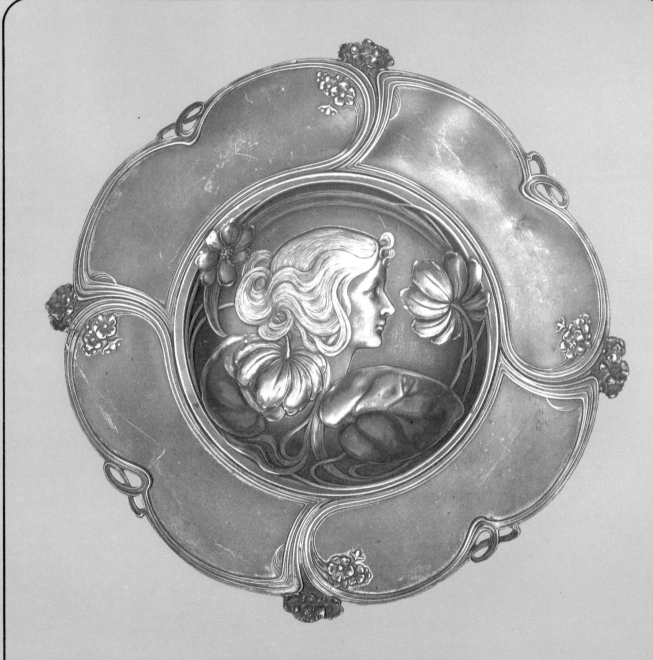

Plate 64

Pewter plaques, usually displaying female and plant forms, were very representative of the period. On the centre of this dish a woman's head emerges from a lily pad.

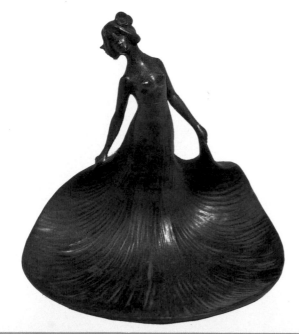

65

Plate 65

This small and graceful dish employs an example of clothes forming an important part of the design. An early example of 'topless' dressing, the woman's body is beautifully modelled, as is the elegant curve of her head, adorned with pansies.

66

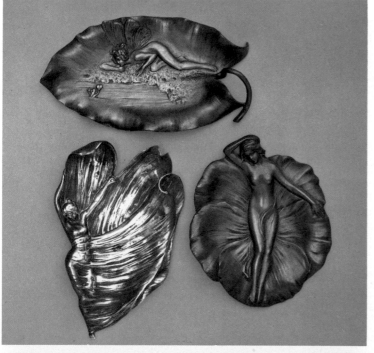

Plate 66

These elegant little dishes (the copper one is 16·5 cm long) all employ the female form in different ways. The two pewter ones also include naturalistic plant forms. The copper dish provides an interesting example of drapery being successfully used to form the main shape of the dish, and might well portray the Parisian dancer Löie Fuller. Such was the attention to detail typical of Art Nouveau that modelling of the woman's right arm and hand is carefully carried out on the underside of the dish. All these pieces display the fairy-tale aspect of Art Nouveau, and were probably mass-produced and exported from France.

67

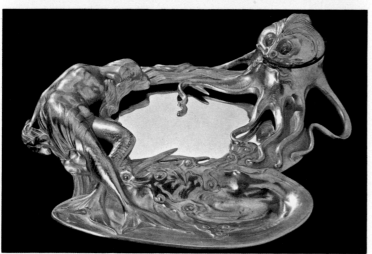

Plate 67

Perhaps one of the most strange and bizarre pieces ever conceived by an Art Nouveau artist is this silver-gilt inkstand, surrealistic in its conception, and embodying one of the favourite themes of Art Nouveau; that of the sea. The sleeping mermaid appears to be at the mercy of the menacing octopus, whose head forms the lid of the inkwell. Bladderwrack seaweed swirls around the water, which is simulated by a patch of mirror.

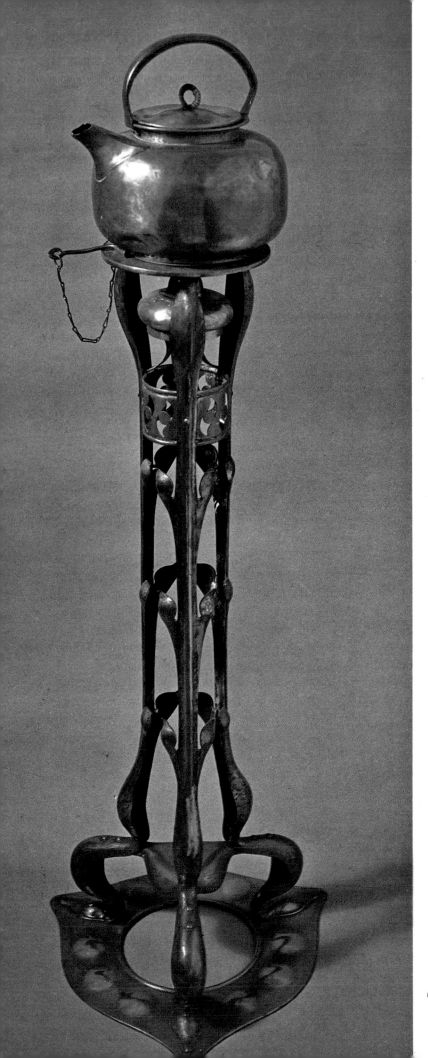

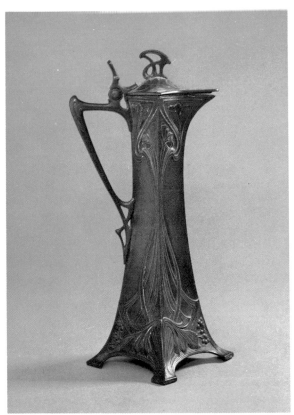

Plate 68

Most certainly made in France this unsigned pewter coffee-pot displays all the characteristics of French Art Nouveau. These may be seen in the asymmetric swirls in the handle and lid knob, and in the symmetric leaf and phallic shape in the surface decoration.

Plate 69

Here a traditionally shaped copper kettle stands on a tall, fanciful pedestal, also of copper, beaten and given Art Nouveau curves and piercings. It is English and was made by Reynolds.

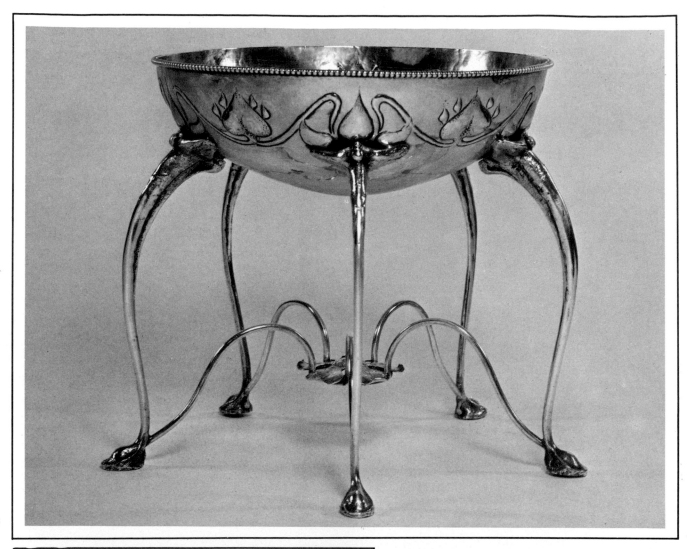

70

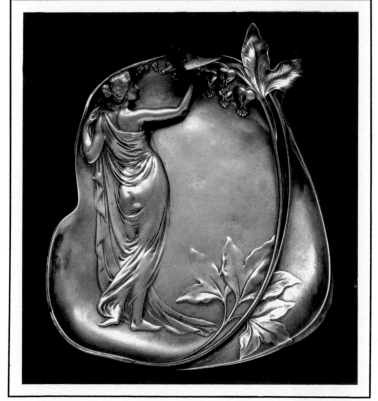

71

Plate 70

Charles Robert Ashbee (1863–1942), although principally an architect, produced some of the most interesting and characteristically Art Nouveau silver. This bowl, typical of his work, was made in 1893. It is embossed and chased with leaves, and has cast legs. It was made by the Guild of Handicraft, which Ashbee founded in 1888.

Plate 71

This wall plaque shows a standing woman sculpted in low relief, while the bird alighting on her hand is modelled completely in the round. Such wall plaques were exported from France under the name *Articles de Paris*.

Fine Metalwork

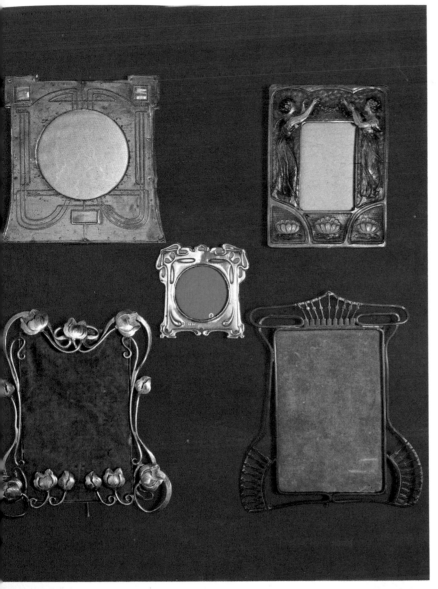

72

Plate 72

These five picture frames clearly illustrate the diverse styles possible within one art form. (Top left) This beaten copper frame inset with mother-of-pearl shows the influence of Mackintosh, and may be an actual piece from his school. (Top right) A moulded frame, the panels on either side are occupied by typical Art Nouveau women, hovering over water lilies. Their arms, holding a garland, stretch across the top of the frame. (Middle) Silver frames such as this, inset with blue-green enamel, were very popular at this time and were often decorated with entwined and overlapping forms. (Bottom left) Brass flowers and stems encircle this frame which, in spite of its symmetry, appears to undulate and flow as if alive. (Bottom right) This severely designed frame, made of brass, was obviously inspired by Egyptian designs.

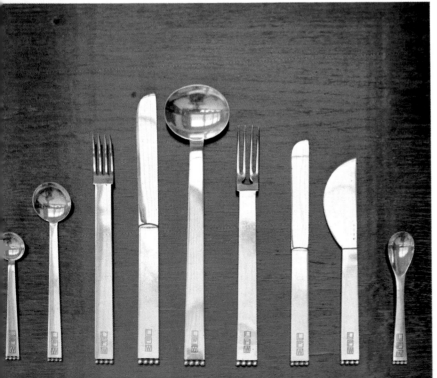

Plate 73

Nothing could be further removed from the fanciful leaf spoons than this cutlery place setting by the Vienna Sezessionist, Josef Hoffmann. Not only do they reveal the very strong influence of Mackintosh, but they are curiously modern, even timeless, in their design.

Plate 74

A striking transformation of natural forms into everyday articles is revealed in these beautiful silver-gilt spoons. The handles, in the form of delicate branches, terminate in leaf-shaped shallow bowls through which run a mass of fine veins. Although unsigned they are very like the work produced by Prince Bogdar Karagerovevitch, a specialist in the design of silverware.

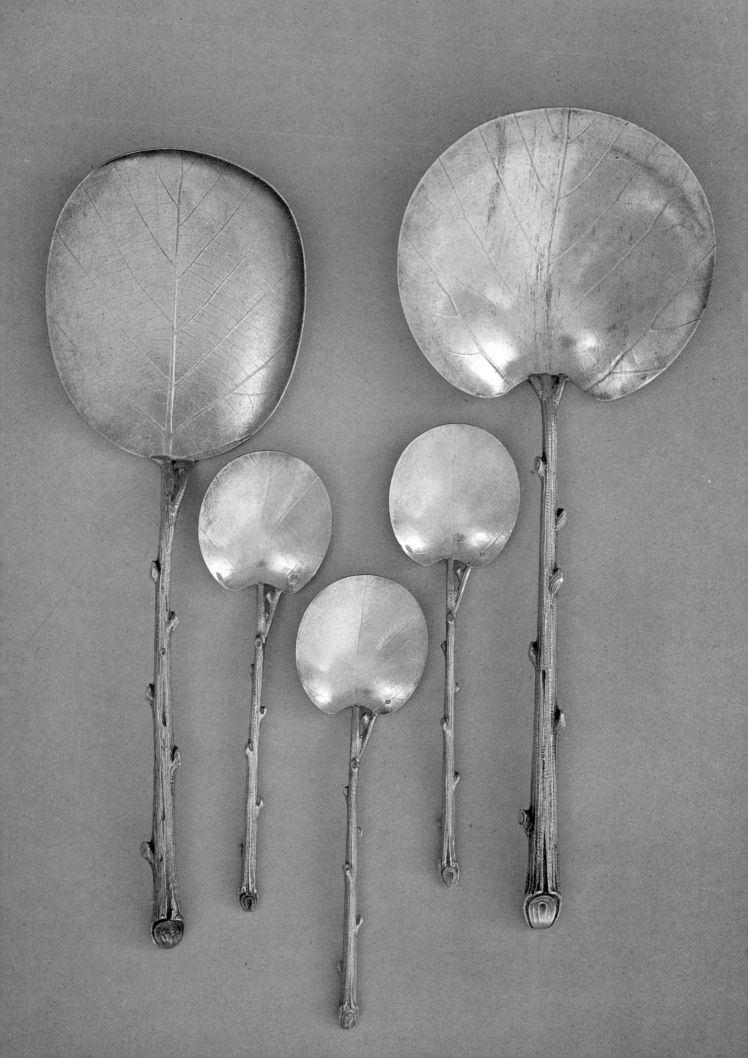

Jewellery

7

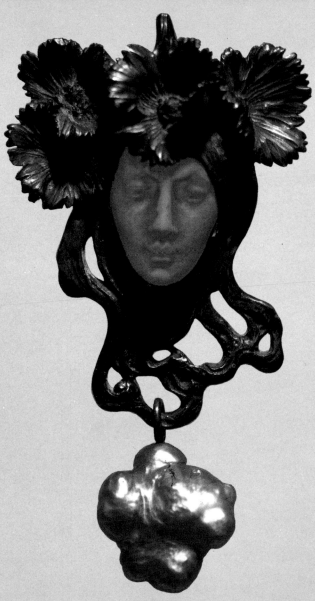

Plate 75

'Splashed with a splendid sickness, the sickness of the pearl.' So wrote the English writer G. K. Chesterton; and this phrase accurately sums up the decadent, *fin de siècle*, aspects of Art Nouveau. Nowhere is it more beautifully realized than in this brooch by Lalique. The baroque (or misshapen) pearl hangs beneath the brooding and mysterious face of a woman, carved out of crystal, wearing a headdress of purply-black flowers upon her flowing black hair, whose tresses gather round her.

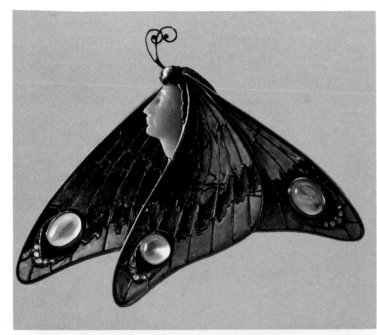

Plate 76

This brooch, by Feuillâtre, reflects the escapist attitude of *fin de siècle* Society, with the delicate, remote profile of the girl, the fairy headdress of butterflies wings and antennae, beautifully modelled in gold filigree, and set with moonstones. Made in France in 1900, it is contemporary with Tinkabell, the fairy in J. M. Barrie's famous play *Peter Pan*.

Plate 77

It is, perhaps, in jewellery that Art Nouveau found its most beautiful and successful expression, and one of its greatest exponents was René Lalique. This centre panel for a choker or dog-collar is one of his finest pieces. It displays a daring and exciting combination of colours as well as being finely executed. The face is carved on chrysoprase (a precious stone of the quartz family) while the hair is chiselled gold.

76

77

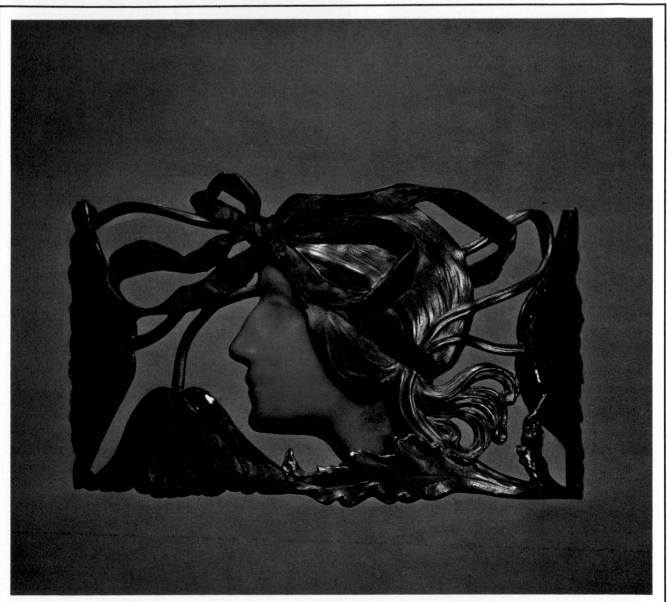

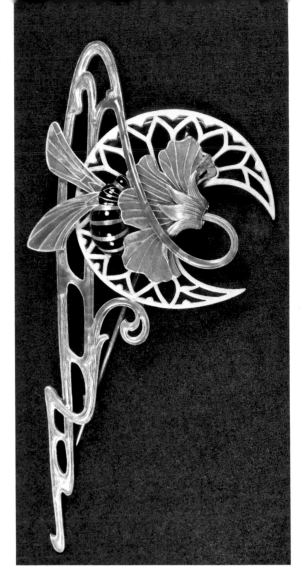

78

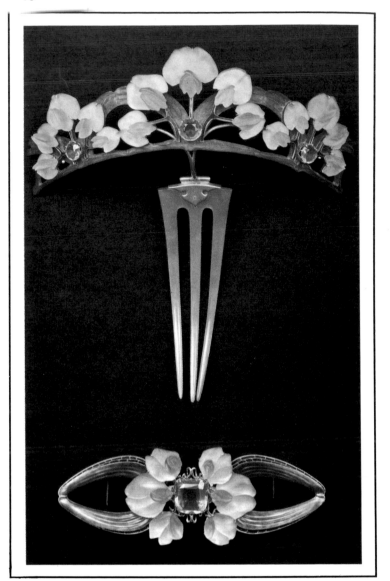

79

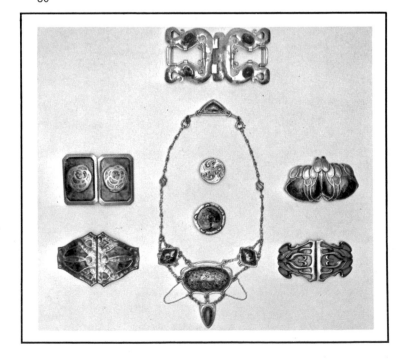

80

Plate 78

Typical of the obsession with plant and insect forms, this brooch displays a bee poised on a convolvulus flower. It is made of gold and *plique à jour*—translucent enamels—and was made in 1901 by C. Dessosiers for Fouquet.

Plate 79

Lalique's mastery of material and form is well displayed in this matching hair ornament and buckle. This set is made of horn, gilded metal, and is inset with carved glass and topaz.

Plate 80

Two of the favourite materials used by Art Nouveau artists working in jewellery were silver and enamel, particularly peacock blue enamel.

Plate 81

One of the most magnificent pieces of jewellery designed by Lalique, this necklace or jewelled collar epitomizes the spirit of Art Nouveau. It is constructed from nine enamel-on-gold panels, linked together by filigree gold mounts, each supporting a round Australian opal.

56

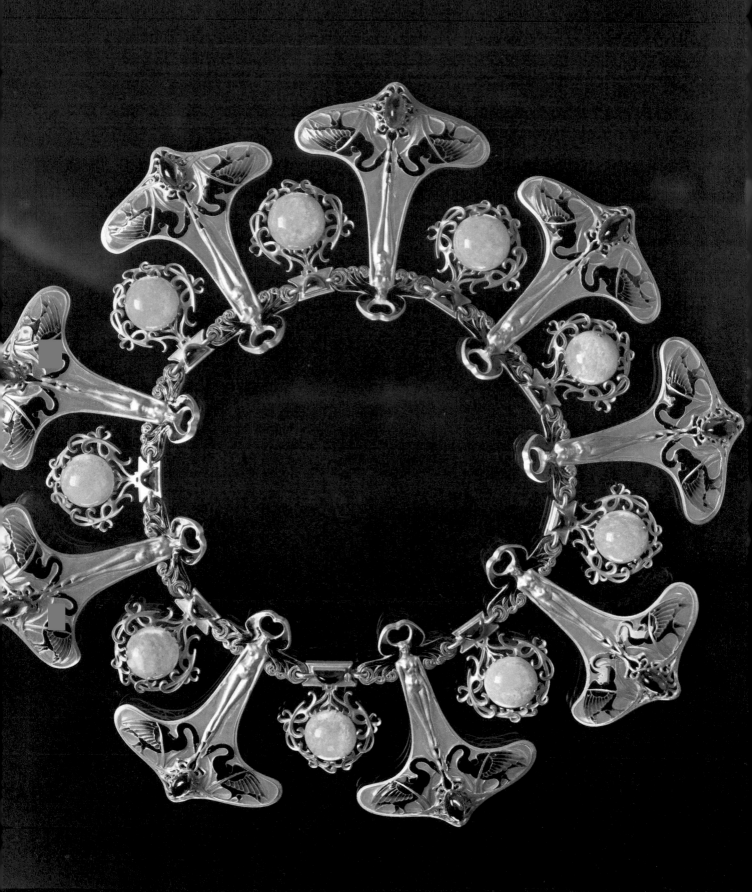

Painting and Sculpture

8

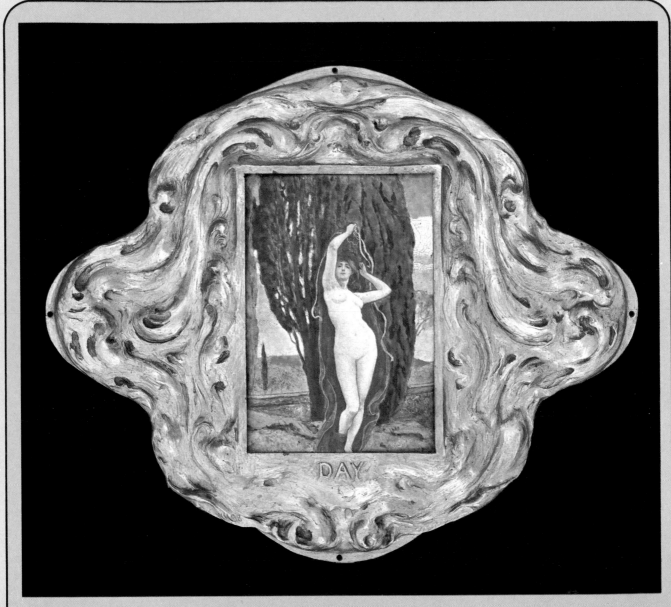

Plate 82
This dashing example of Art Nouveau painting by the Royal Academician Sir Herbert Herkomer, was painted in 1898. Entitled *Day*, and in its flowing gilt frame, it tells us much about the *fin de siècle* spirit in England. Unlike Klimt's women, the completely nude figure here seems cold and passionless, and represents an ideal and acceptable English interpretation of the female form. On the other hand the trees and landscape appear, like the frame designed by the artist, wild and painterly.

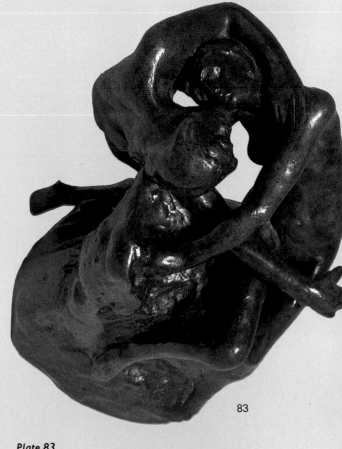

83

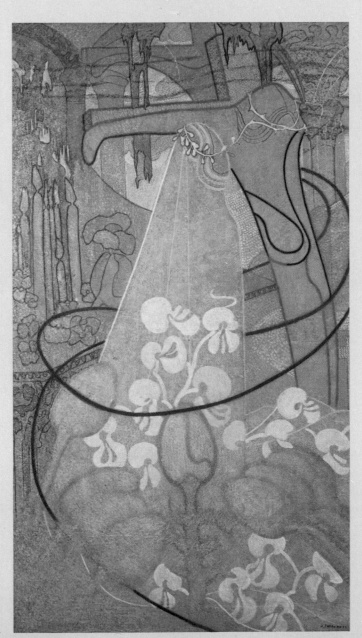

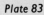

Plate 83

Auguste Rodin (1840–1917), whose work has been described as both neo-Baroque and Romantic, shares with many Art Nouveau artists, in spite of his unique surface treatment, the same fluidity of line and the tendency to suggest some hidden meaning. This small group, *The Secret*, reflects the Art Nouveau influences of the period. He strongly influenced Minne with his sense of movement, though his personal sensuality was foreign to the other sculptor.

Plate 84

The subject of this painting by Johannes Thorn Prikker (1868–1932), entitled *The Bride* and executed in 1892, is perhaps a nun taking the veil, enveloped in a garment decorated with white flowers that take on the shape of skulls. She is linked to the figure of Christ hanging on the cross by her garland of myrrh, which becomes, round his head, the crown of thorns. In the foreground phallic tulips appear to reach forward to engulf her, while in the background a group of candles burn, their pale flames reaching up into the vaulting. The artist has used cool blues, mauves, lilac and gold, to blend the whole scene together.

84

Painting and Sculpture

Plate 05

Samuel Bing, who founded the first Art Nouveau shop in Paris in 1889, commissioned the young Frank Brangwyn (1867–1956) to cover the whole shop façade, in the rue de Provence, with murals. 180 feet long, they were painted on canvas and mounted on to the building. He also executed similar works for the entrance hall, of which *Music*, shown here, is one.

Plate 86

The idea that man and nature, even if in conflict, are one, pervades much of Art Nouveau work. In this religious painting *The Chosen One*, the Swiss painter Ferdinand Hodler (1853–1918) shows the infant Christ, surrounded by angels, kneeling before a small sapling. It was specially executed for Henri van de Velde's Hohenhof, in Vienna.

Plate 87

Between 1905 and 1911, Josef Hoffmann built the Palais Stoclet in Brussels. Too dramatic for a private house and more Cubist than Art Nouveau, it nevertheless contains mosaic murals by Gustav Klimt which are perhaps his masterpiece, consisting of highly stylized trees punctuated by single or embracing figures. This drawing is a detail of a cartoon for one of the women.

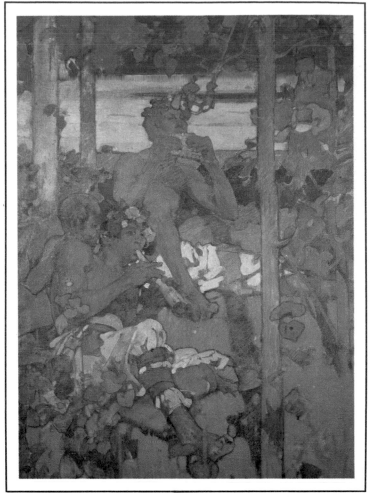

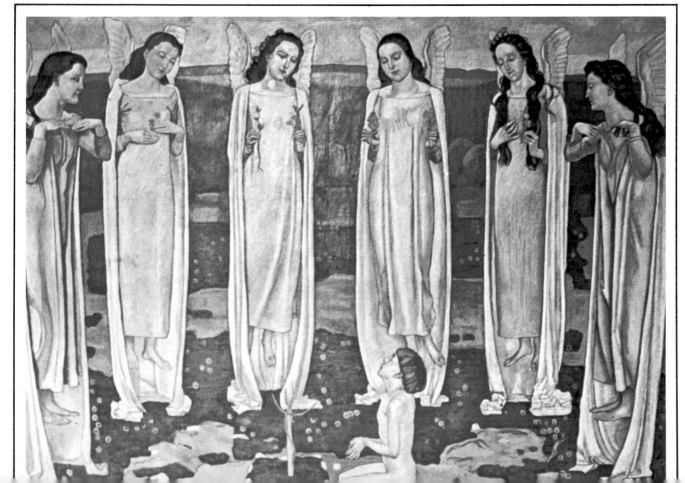

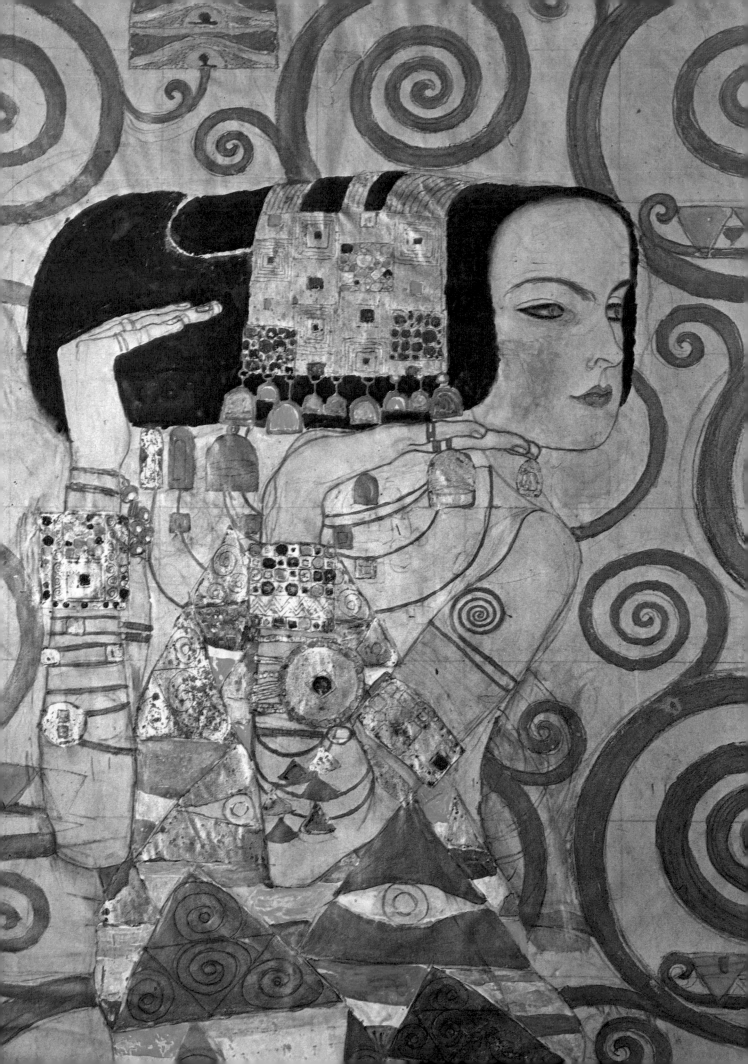

Painting and Sculpture

Plate 88

Sarah Bernhardt, known as 'the Divine Sarah', was a great patron of the Art Nouveau movement. René Lalique made jewellery for her, Alphonse Mucha and Eugene Grasset created posters, while this bronze statuette depicting her in the title role of Rostand's drama *The Princess Lointaine*, is by Marius Vallet.

Plate 89

Unhappy in love, Munch's view of women was pessimistic. He felt that, like vampires, they would devour him. In this painting, *The Dance of Life*, completed in 1900, the young man in the foreground dancing with the girl in the flowing red dress, symbolizing passion, is watched over anxiously by two women, one in white, symbolizing youth and purity, the other in black, signifying death. The whole scene is redolent of the oppressive *fin de siècle* spirit.

Plate 90

A star of the Folies Bergère, Löie Fuller, whose famous scarf dance caused a sensation, as she whirled and spun like a top, was the embodiment, even a symbol, of the Art Nouveau spirit. This exquisite bronze figure of her, after a model by Agathon Lèonard, is called *Le jeu de l'Echarpe*, and is dated about 1900.

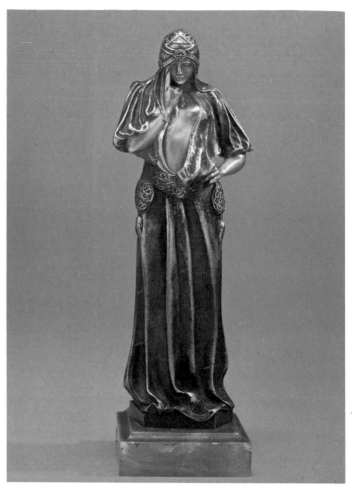

88

89

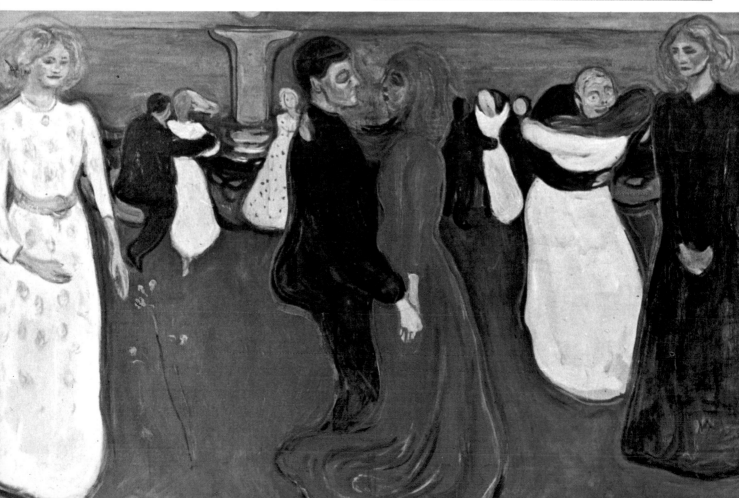

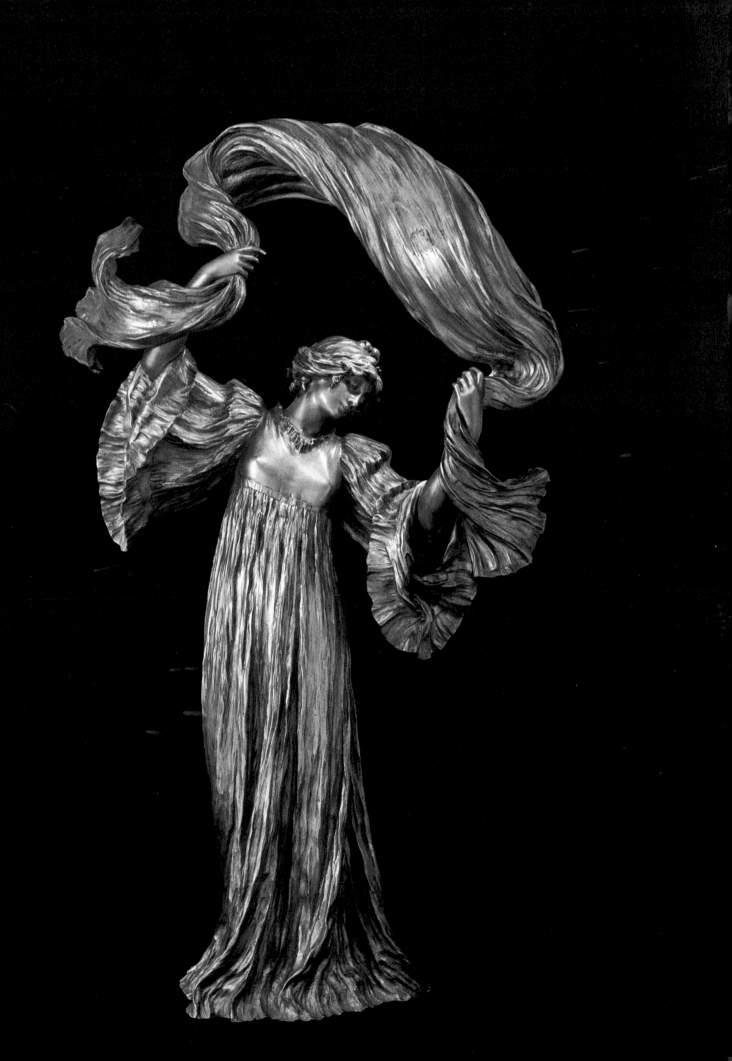

Painting and Sculpture

Plate 91

This anonymous bust by an Austrian sculptor is of Daphne: cool and remote, beautifully modelled and serene, very much in the manner of Sappho

Plate 92

The epitome of Art Nouveau—the feminine form, plant form and translucent colours; all are here in this bronze and enamel bust by the French artist Godet. The plant from which the woman emerges, and the petals round her head, even resemble the veins and markings of butterflies so that the whole exquisite rendering suggests fragility as well as solidity.

Plate 93

Sappho, the great classical Greek writer in the seventh century BC, gathered around her a group of women interested in music and poetry. In this terracotta bust by S. Obiolo, her temples are adorned with pale poppies, while her thick hair falls upon her breasts, both draped and revealed by a green shawl drawn about her shoulders.

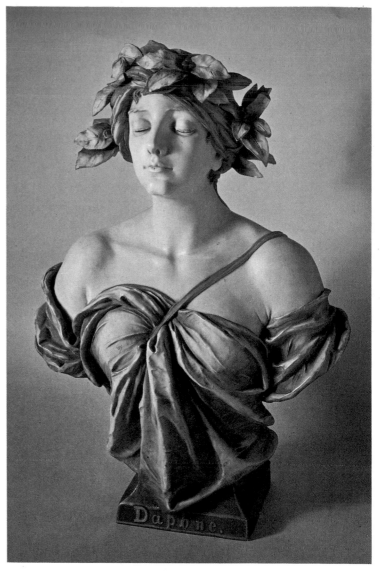

91

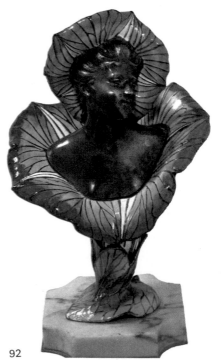

92

64

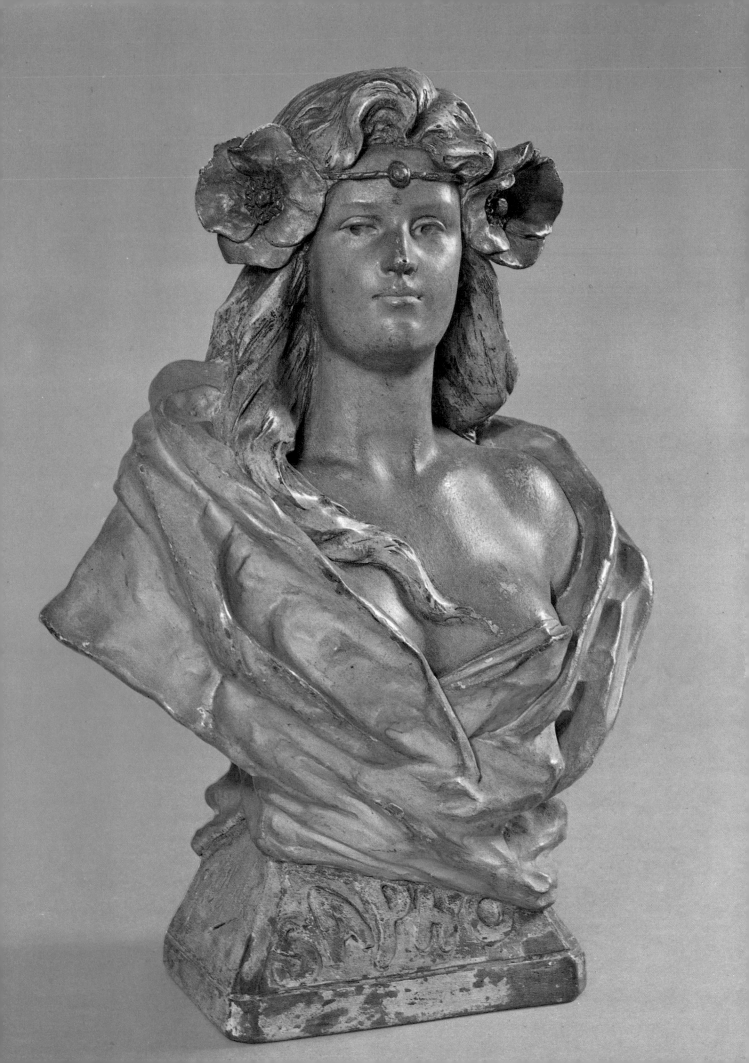

Graphics and Books

9

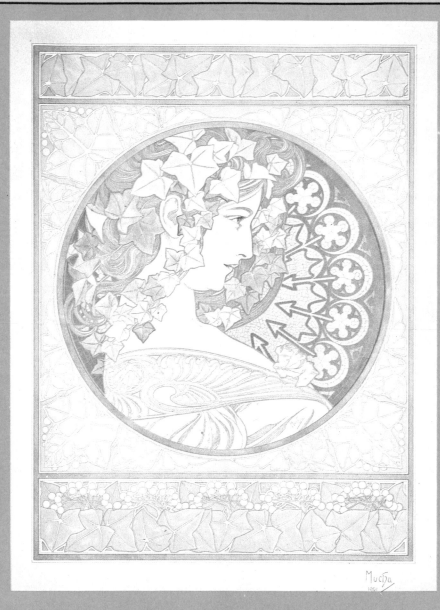

Plate 94

One of a pair of lithographs by Alphonse
Mucha, it successfully combines plant and
geometric motifs to enhance the simple profile of
a young woman wearing a superb Art Nouveau
gown and is more softly coloured than is usual
with this artist. Note the mosaic treatment in
the background, and the repeated pattern of
naturalistic vine leaves surrounding her.

94A

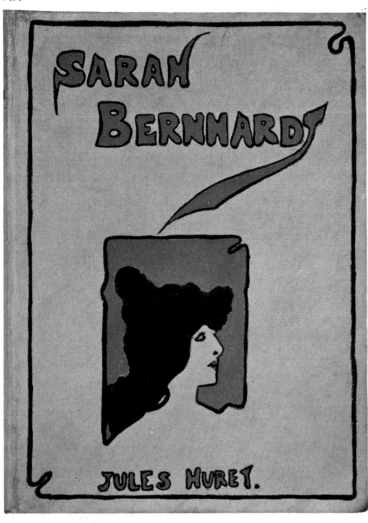

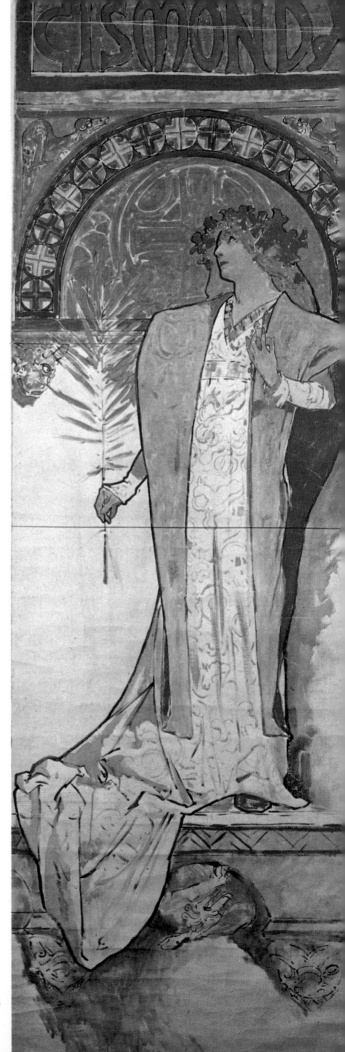

Plate 95A, B

In her day Sarah Bernhardt was given the same
kind of star treatment later accorded to the
great figures of Hollywood. Her reputation was
world-wide, and many books (A) were
written about her. In the poster (B) by Alphonse
Mucha, she stands robed in a flowing gown,
in her left hand she holds an olive branch,
while her head is posed dramatically against a
gold circlet or halo.

95B

Graphics and Book Design

Plate 96

This little book, *Love Poems of Tennyson*, was published by Beardsley's publisher, John Lane, in 1901. Every page has decorative borders in violet, while the text of the poems is printed in green. The cover is typical of its *genre*, blocked in gold with a design of stylized flowers and delicate, interlacing vegetation.

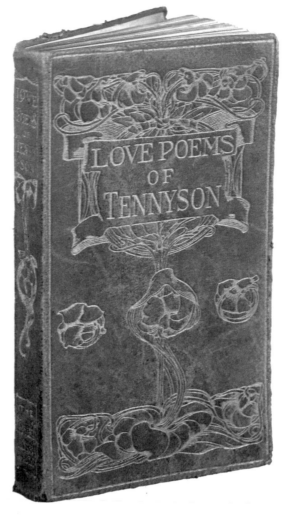

96

97

Plate 97

This book cover for *Le Morte d'Arthur* by Sir Thomas Mallory, published by Smithers in 1893, was designed by the British artist Aubrey Beardsley. The stylized irises on long stems carefully balance each other, and the whole design gains interest from the third bloom placed at the optical centre of the book. The simple tooled frame has only a single line at the foot, two at the head, while the three lines on either side have been skilfully joined to the overall design.

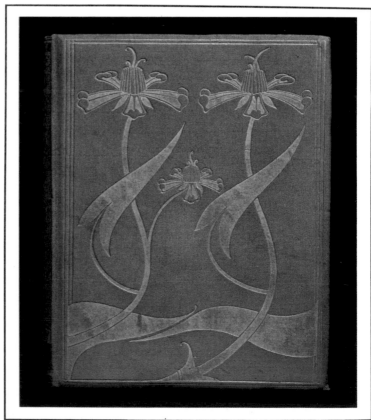

Plate 98

This beautiful drawing was reproduced on the May 1900 cover of *Jugend*, the Munich fine arts journal from which the German style of Art Nouveau received its name: *Jugendstil*. The well-known graphic designer Otto Eckmann (1865–1902) and the artist Ernst Barlach (1870–1938) both worked for the journal between 1897 and 1902.

1900 · 14. MAI · JUGEND · V. JAHRGANG · NR. 20

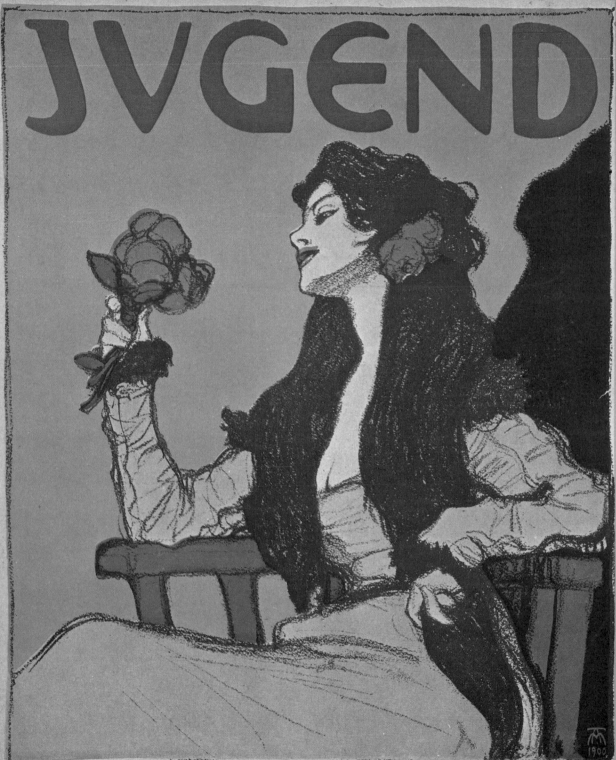

JVGEND

Münchner illustrierte Wochenschrift für Kunst und Leben. — G. Hirth's Verlag in München & Leipzig.

Graphics and Book Design

Plate 99

Walter Crane (1845–1915), founder member of the Art Workers' Guild in 1884, was one of the most prolific and successful illustrators of children's books at the end of the nineteenth century. Like Blake, and his own contemporaries Morris and Beardsley, he strove for unity of illustration and text. His books have imagination and charm, as in this page from *Flora's Feast*, which he produced in 1889. In this book flowers are personified in human and animal forms, many in sweeping Art Nouveau shapes. He was highly regarded on the Continent, as an important exponent of the 'English Style', and exhibited in Paris and designed covers for books there.

Plate 100

Only a year after its inception in 1897, the Vienna Sezession group published its official journal *Ver Sacrum* (Sacred Spring). Contributors included Josef Hoffmann and Josef Maria Olbrich, founders of the movement. A typical spread from the journal is shown here; it was contributed by Kolo Moser (1868–1918), painter, designer, and graphic artist.

Plate 101

As well as designing theatre posters, Mucha also worked on more mundane commercial ventures, such as this postcard advertising cigarettes. At this time it was considered very daring for women to smoke, so that this particular picture must have been regarded with a sense of shock when it was first produced.

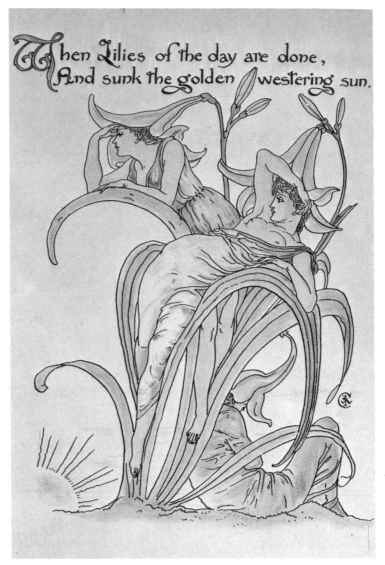

99

100

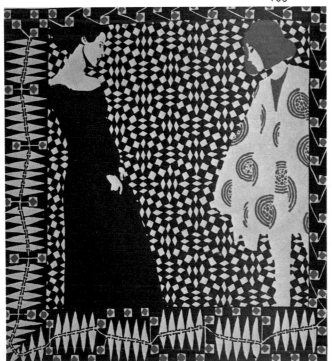

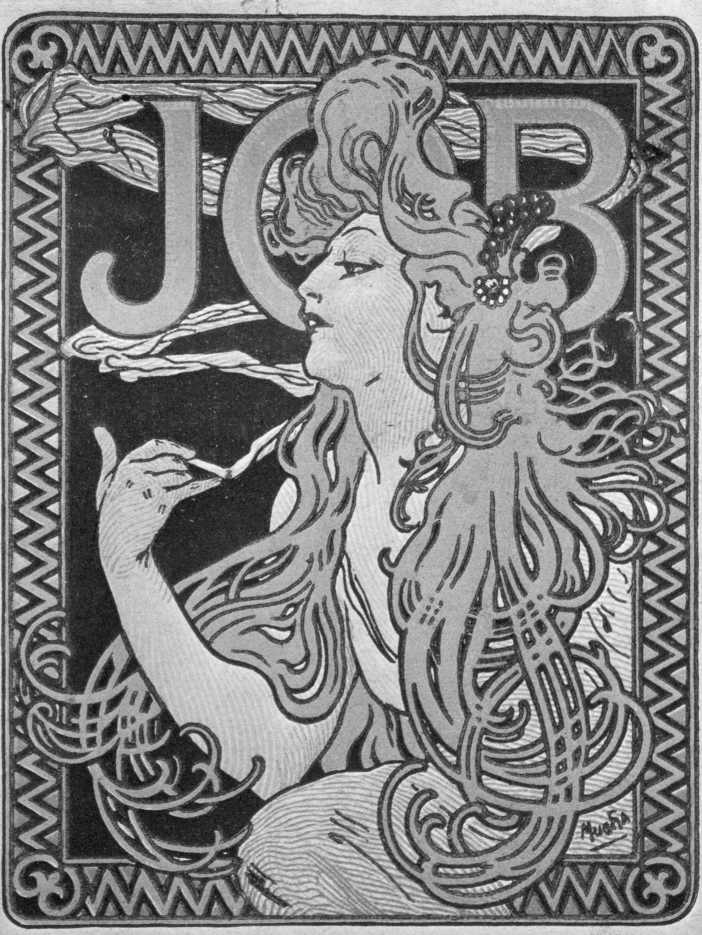

ACKNOWLEDGMENTS

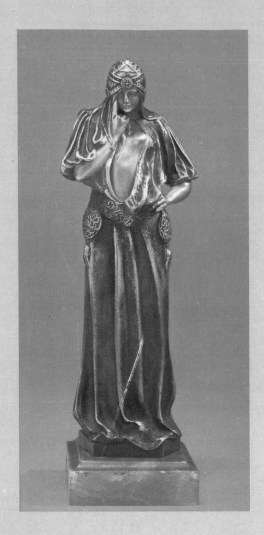

The author wishes to thank the following for kindness in lending items from their collections and for the assistance of their knowledge of the subject: Mrs Lillian Nassau of the Lillian Nassau Gallery, New York, Mr Victor Arwas of 'Editions Graphiques', London, and Mr Michael Andrews of 'The Emporium', Bournemouth. The author wishes to thank the following for their help and co-operation: Mr Ronald Setter, Mr Paul Forrester and Mr John Parsons.

Publisher and author would like to express their grateful thanks to the following individuals and organizations for their help in providing colour transparencies or items for special photography: Mr Michael Andrews, plates 14, 47a, 64, 65, 66; Bethnal Green Museum, London, plates 38, 39, 40, 44, 45, 46, 50, 51, 52, 56, 62 (all Crown Copyright); Editions Graphiques Gallery, London, plates 8, 10, 17, 48, 49a, 58, 59, 60, 61b, 63, 67, 80, 82, 88, 90, 91, 92, 94; Mr Thomas Feist, plates 33, 54, 55; Geffrye Museum, Shoreditch, London, plates 4, 37, 69 (on loan from the Victoria and Albert Museum); Mr Keith Gibson, plates 27, 28, 29b, 42; M J Guillot – Connaissance des Arts, plates 26a, 26b; Calouste Gulbenkian Foundation, plates 7, 12, 75, 77; The Hamlyn Publishing Group, plates 27, 28, 29a, 31; Mr Nelson Hargreaves, plates 6; Haworth Gallery, Accrington, plate 13; Karl-Ernst-Osthaus-Museum, Hagen, Germany, plate 87; Klingspor Museum, Otterlo, Holland, plate 84; Mansell Collection, London, plates 99, 101; William Morris Gallery, Walthamstow, London, plates 1, 2, 83, 85; Munchener Stadsmuseum, plate 5; Munch-Musset, Oslo, plate 89; Museum of Modern Art, New York, plate 34; Lillian Nassau Gallery, New York, plates 33, 54, 55, 81; Mr Van phillips, plates 19, 20, 22, 23, 41; Réalites, plates 26b, 95b; Sully-Rapho, plates 24, 26; Sunday Times Syndication, plates 43, 86, 100; Victoria and Albert Museum, Crown Copyright, plates 70, 78, 79; M J P Ziolo, plates 25, 30, 76, 95b, 98.

The author also wishes to thank Mr Anthony Denney for the loan of his ornaments in plate 7.

Special photography for many of the items illustrated was undertaken by Michael Dyer Associates, as follows: plates 1, 2, 4, 9, 10, 11, 14, 16, 17, 18, 35, 36, 37, 38, 39, 40, 43, 45, 46, 47a, 47b, 48, 49a, 49b, 50, 51, 52, 53, 56, 57, 58, 59, 60, 61, 62, 63, 64, 65, 66, 67, 69, 71, 72, 74, 80, 82, 83, 85, 88, 89, 91, 92, 93, 94, 95a, 96.

Items illustrated in plates 16, 35, 47b, 53, 57, 61a, 68, 71, 72, 74, 93, 95a, 96 are from the author's collection.